CAT IS ART SPELLED WRONG

Cat Is Art Spelled Wrong

Essays

Edited by

Caroline Casey

Chris Fischbach

Sarah Schultz

COFFEE HOUSE PRESS

MINNEAPOLIS, 2015

This book has been produced in partnership with the Walker Art Center.

Coffee House Press books are available to the trade through our primary distributor, Consortium Book Sales & Distribution, cbsd.com or (800) 283-3572. For personal orders, catalogs, or other information, write to: info@coffeehousepress.org.

Coffee House Press is a nonprofit literary publishing house. Support from private foundations, corporate giving programs, government programs, and generous individuals helps make the publication of our books possible. We gratefully acknowledge their support in detail in the back of this book.

PERMISSION

"Poem (As the cat)" by William Carlos Williams, from *The Collected Poems Volume I, 1909–1939*, copyright © 1938 by New Directions Publishing Corp. Reprinted by permission of New Directions Publishing Corp.

LIBRARY OF CONGRESS CATALOGING-IN-PUBLICATION DATA

Cat is art spelled wrong / edited by Caroline Casey, Chris Fischbach, Sarah Schultz.
pages cm
ISBN 978-1-56689-411-1 (paperback)
1. Cats—Humor. 2. Internet videos—Humor. I. Casey, Caroline, 1976– editor. II. Fischbach, Chris, 1972– editor. III. Schultz, Sarah, editor.
PN6231.C23C345 2015
818'.602—dc23
2015014710

PRINTED IN THE UNITED STATES OF AMERICA

FIRST EDITION | FIRST PRINTING

CAT IS ART SPELLED WRONG

CONTENTS

WE WENT TO THE FIRST Internet Cat Video Festival as an office. We'd been going to Open Field, the Walker Art Center's "happy mutant smorgasbord" for outdoor, madcap, and inspired fun, all summer, and this seemed like the perfect way to cap the season. Though in Minneapolis in August, you don't need much of an excuse to spend an evening outside on a blanket with friends. But that night was something that no one—our small group from Coffee House, the Walker curators and programmers, the media in attendance, the people who came in full cat regalia—expected. It was magical. What did it mean to feel joy in sync with 10,000 other people? How did that happen? By the time *Henri, le Chat Noir* had been awarded the Golden Kitty (the Oscar of cat videos), we knew we wanted to answer those questions.

There's something about cat videos. There's something irresistible about them that doesn't transfer to dog videos, or parakeet videos (though baby goat videos might come close). And there's something about experiencing a phenomenon and pleasure particular to the internet, offline. But what's so special about watching what is essentially YouTube with a few thousand strangers? Why do that, anyway? Because people watch cat videos together—they have in Minneapolis (three times now), Honolulu, Providence, Los Angeles, Athens, London, and other cities. More than 100 times, all told.

Over the past three years, Coffee House Press has been collaborating with the Walker Art Center to answer these questions. We put together a list of writers we loved, we thought a lot about Carl Wilson's *Let's Talk About Love* (our urtext), and we Kickstarted the project with the help of a few

hundred supporters. What came together was as unexpected and delightful as that first night watching "Keyboard Cat" and "Kittens Inspired by Kittens" and "Boots and Cats." It's about cat videos as poetics and politics. It's about the boundaries of what art is, about spectacle and the communal and the personal, and about all of the places those things overlap. It's about an eighteenth-century cat, and Felix the Cat, and contemporary art, and #catsofinstagram.

As Will Braden, creator of *Henri, le Chat Noir,* said in our first meeting, the interesting thing about cat videos is that they're really about people.

Here are some of our favorite people on what it means to be a person at this moment in time, i.e., a person who watches cat videos.

—Coffee House Press

CAT IS ART SPELLED WRONG

MARIA BUSTILLOS

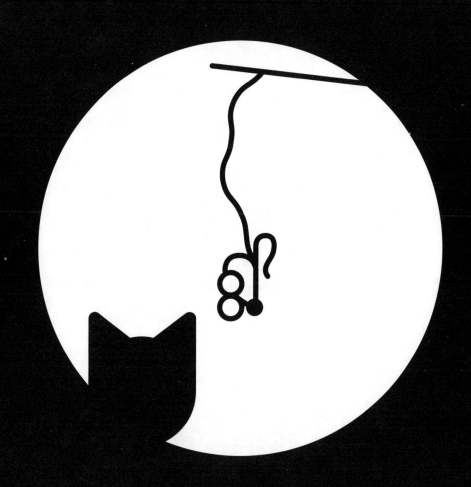

HOPE IS THE THING
WITH FUR

I ONCE DREAMED I WAS A GRAY KITTEN of perhaps four months of age; in the best part, I jumped from a table onto the distant wooden floor. The soft pads of my paws cushioned my landing in a deeply pleasurable and unexpected manner, and I found myself sashaying around and swishing my tail in contentment. This dream (a favorite, and one I often relive in memory) demonstrated my long-held belief in the many superiorities of cats to humans. The bodies of cats are exquisitely mobile; they can leap huge distances relative to their size; they are fast and alert and elegant; they have long, sensitive whiskers and delicate ears that can focus in any direction they choose. They can purr, communicating a delight that reverberates through their whole bodies. They also sleep half the day! There's so much to envy there. So much to admire.

Before we enter into the question of cat videos, we must talk about cats themselves. Cat videos are the crystallization of all that human beings love about cats, the crux of which is centered in the fact that cats are both beautiful and absurd. Their natural beauty and majesty are eternally just one tiny slip away from total humiliation, and this precarious condition fills us with a sympathetic panic and delight, for it exactly mirrors our own. The director of a cat video is thus typically motivated either by an unmixed appreciation and love for the excellence or cuteness of his subject or by a desire to capture a cat in a dignity-impaired moment. Those videos that succeed in communicating both admiration and ridicule are perhaps the best ones of all, producing the most loved characters in the genre (e.g., Maru, Henri the Existential Cat, Surprised Kitty, and so on).

In this way, cats exactly reflect our feelings about ourselves. To demonstrate, let us consider Hamlet's complicatedly sarcastic views on the ridiculous and the sublime in man, with one small substitution:

> What a piece of work is Cat! How noble in reason, how infinite in faculty! In form and moving how express and admirable! In action how like an angel! in apprehension how like a god! The beauty of the world! The paragon of animals!

But notice how it doesn't work at all if you should substitute turtle or chicken or cow for cat, here. Even the estimable dog doesn't quite work in the subject passage, for dogs, while they may from time to time be noble in reason and express and admirable in form and moving, are not quite infinite in faculty, nor godlike in apprehension; dogs are in general simpler and more trusting, and lack the extra dimension of mystery that belongs to cats, and to ourselves. Cats share something more with us than mere creatureliness: They share, somehow, our central predicament. Beauty and panic, laziness, and the potential for real idiocy. A certain predisposition to cruelty and indifference, mixed indiscriminately with a certain unaccountable warmth and gentleness. Each one different, unpredictable, full of surprises. What we can but dimly apprehend of our own condition, we can readily see and identify in cats.

"He thinks he's a person," people will say, when what they really mean is that *they* think so.

Return with me, then, to the dawn of the internet, to those days of wonder and delight before any of us had heard of Twitter or Facebook; before Anonymous, before the revelations of Edward Snowden, before BuzzFeed, before even Google. Before all the terrible things Adrian Chen wrote about at *Wired* in October of 2014.[1]

At the close of the twentieth century, the dissemination of cat videos was but a distant dream, owing to the minute amount of bandwidth that even the fanciest computer systems could provide to the early "web surfer." On a 56K modem, it would have taken ages and ages to download a single one of the cat videos we can blithely knock back by the dozen today.

But there was something coming, that much was clear from early portents. Something hilarious, something absurd, something infinitely compelling. The website hampsterdance.com went live in late 1997 or early 1998, and by the following year, a quarter of a million visitors were tuning in every day to hear a weirdly addictive audio loop consisting of twangy music and an infernal giggle, which accompanied the rudimentary animation of rows of dancing hamsters. Well, "dancing" is a bit much to say—it was more bopping, ambling, or quietly rotating. "Legions of dancing hamsters will drive you mad with their inane de-do-de-do he-he-he!" promised one viewer, accurately.[2]

The avalanche of interest in thoroughly idiotic videos of ridiculous animals was barely beginning. But with each increase in bandwidth came a slightly more sophisticated video, and another, until there were countless thousands. By 2002, Joel Veitch of rathergood.com had created his first primitive Kitten Band, soon to be joined by the irresistible Punk Kittens, Northern Kittens, Gay Bar Kittens, and Sweary Kittens. The apotheosis of Veitch's cat video oeuvre would, however, not come until 2010, with "The Internet Is Made of Cats," a work that joins a snappy, sing-alongable tune to internet cat scholarship of a very high order, observing, "The Internet Is Made of Cats: Cats! Cats! Cats! Cats Cats!" and telling the tale of the cat-god "powerful beyond imagination," Maru, who would manipulate the cosmos in order to summon the savior of the Internet Cat Race.[3]

Maru (まる, Japanese for "circle" or "round"), emperor of internet cats, requires a moment of reflection on his own. He is "a boy of Scottish Fold" and "a lazybone basically," belonging to the Japanese YouTube user mugumogu, whose videos have racked up millions of views. Maru is so resplendently beautiful, so thickly furred and magnificent, and so utterly mellow that even watching mugumogu clean his ears with Q-tips is an entirely relaxing and pleasurable experience. But Maru is also a kook, and it is this kookiness that is responsible for the love his legion of fans bears him. Maru is perfectly capable of making a fool of himself over a bit of string, and he can fall off a cat tree with the best of them—but it is his determination to inhabit every available box, no matter how small or

inconveniently situated, that seals his greatness and ensures his immortality. He's a master, the Michael Jackson of the cat video world, whose performances are as fresh and appealing today as they were six years ago when he made his debut in "まるです" ("I am Maru"), the video in which he first beguiled the world by lying on his back in a bathroom sink, swatting a ball on a string, and bounding across the floor and into his first box.

No one will argue that there is much to regret about the evolution of the web since it took off in 1989. But against the swamps of Reddit, the deplorable authors of GamerGate, and all the horrific incursions of the Man, we may measure the lush, quiet satisfaction of watching Maru hurl himself into a box and then lie comfortably still, plump hind legs splayed, luxuriant tail swinging contentedly back and forth.

Such pleasures recall the words of Evelyn Waugh regarding P. G. Wodehouse, whose works similarly provide us with a balm against the sadness and grief of the world. Wodehouse, Waugh observed, had made for us an "idyllic world [that] can never stale." His characters "exist in a world of pristine paradisal innocence. For Mr. Wodehouse there has been no Fall of Man. . . . His characters have never tasted the forbidden fruit. They are still in Eden."[4]

So it is with the feline demigods who kindly soothe away our daily hurt by falling off a wall, sleeping with a pit bull, or purring in a box on the internet. Cat videos too "will continue to release future generations from a captivity that may be more irksome than our own." They too are "a world for us to live in and delight in." They are the internet's crowning achievement, a realm of universal mirth and innocent fun.

The charm of cat videos crosses all boundaries of class, gender, and nationality. Of what other medium can this be said? Cat videos are the ice cream of moving imagery, a lingua franca rivaling or perhaps even surpassing that of Disney cartoons or action movies almost universally understood and adored. Those few impoverished souls who cannot yet find it in them to adore may seem to the rest to be suffering from an attack of biliousness from which one cannot help but hope they will soon recover.

Aside from their philosophical function, and their function as an international language of friendship and fun, cat videos serve a number of other valuable purposes worth mentioning. A cat video is ideal for use as an olive branch after a dispute; it's the perfect undemanding and friendly hello to a distant friend, intimate without being intrusive. The cat video can lend a welcome note of silliness to lighten the tone of a flirtation, or to express a bit of mirth to a grouchy coworker. They make every message to which they are appended feel softer, lighter, easier.

As I write this, the sleek, ebony-black Sam is purring in my lap. How to describe our long companionship? In all the conventional ways, of course: "He's a member of the family," "He's just a big old baby," and "He's a very good boy." Sam showed up in our backyard fourteen years ago, a tiny kitten in the company of his stray mama and siblings, all of whom were more conventionally attractive than he: there was a lovely tabby one and another like a puffy ball of gray smoke. I was able to find homes for them very easily. But it was Sam, with his great golden eyes and playful, even slightly rascally manner, whom my daughter begged us to keep. (We've never yet made a video of Sam, though he is by far the best laser-pointer hunter I've ever seen, and it would be fun to show off his prowess.) In any case, there's nothing but goodness and love that has come of taking care of this little cat—even if he is making it harder to type, at present. Loving a cat is a way in which a person can feel and express goodness and happiness, and cats express these things back to us in return. The cat video documents it all, in a form we share all over the earth.

Most of us get to know only a few cats intimately IRL (though I've met heroic rescuers of hundreds or even thousands of them, like Ben Lehrer of Kitten Rescue, a favorite charity here in Los Angeles). But through cat videos, we admirers of cats can know any number of them intimately and recognize multitudes of others like ourselves in Japan and Russia and France and everywhere else. The internet is home to millions of records of people just quietly at their best, sharing love and humor with a pet. Here are serious philosophical implications that it would be foolish to discount.

It's all too easy to see how the sad idea of a vengeful God has taken hold throughout human history, our perilous situation and the mysteries of the cosmos being what they are. For if I were God, and I were to come back after a few millennia to see how the planet I had made was faring, and I found human beings had grown so senselessly cruel, so ignorant and destructive, and visited such ruin on their beautiful home, their fellow creatures, and on one another, I can well imagine wanting to smite them to pieces and send along a lot of frogs and locusts and boils and things to reckon with. Maybe even wipe them out completely for making such a godawful mess.

But—even then—if, before I smote, I were to chance on a video of a cat riding placidly around on a Roomba? Then I believe I would have to spare the human race, keep the jury out, give another chance: forced as I would be, in the face of this incontrovertible evidence, to conclude that there was something in us still worth saving.

Notes

1. Adrian Chen, "The Laborers Who Keep Dick Pics and Beheadings Out of Your Facebook Feed," *Wired*, October 23, 2014, http://www.wired.com/2014/10/content-moderation.

2. "Hamster Dance Screen Saver," accessed July 1, 2015. http://www.wischik.com/scr /savers/HamsterSaver-setup.html.

3. "The Internet Is Made of Cats," *Rathergood*, January 14, 2010. http://www.rathergood .com/cats.

4. Evelyn Waugh blurb on P. G. Wodenhouse books, as published by Penguin.

JILLIAN STEINHAUER

THE NINE LIVES OF CAT VIDEOS

The position that an epoch occupies in the historical process can be determined more strikingly from an analysis of its inconspicuous surface-level expressions than from that epoch's judgments about itself.
—Siegfried Kracauer, "The Mass Ornament"

The spectacle creates an eternal present of immediate expectation: memory ceases to be necessary or desirable.
—John Berger, "Why Look at Animals?"

1

One evening in the summer of 2013, I joined 11,499 other people—give or take—at the Minnesota State Fair Grandstand to sit and watch cat videos. I had spent the day leading up to the Internet Cat Video Festival (or CatVidFest, as it's nicknamed) wandering the fair in extreme heat, eating

assorted fried foods on sticks, watching butter sculptors, and paying money to take off my shoes and traverse an artsy blow-up castle with "rooms" of saturated color (think Dan Flavin goes to the fair). Hours later, dehydrated and probably sunstroked, I met up with a journalist from Minnesota Public Radio for a brief interview.[1] He wanted to talk to me because I was an art critic, and because I had served as a juror for that year's CatVidFest.

Seeking a relatively quiet place, we sat down on a concrete ledge just outside the Grandstand. As he readied his equipment, I readied myself, trying to pull together some thoughts about the jurying process and my love of cats. He was friendly, and we started with a brief introduction, a little banter to ease the awkwardness. Then he got serious and posed the Big Question he'd clearly come (and/or been sent) to ask: "Are cat videos art?"

It was, somehow, a query I hadn't expected, even though I was in Minneapolis specifically to attend a festival of cat videos put on by an art museum (the Walker Art Center). I suppose this was because I found the question absurd—not to mention unanswerable and inaccurate. Asking me to determine if cat videos, in general, were art seemed like asking beauty pageant contestants to deliver a concise but convincing vision for the attainment of world peace. It was a question without an answer.

In her essay "Trash, Art, and the Movies," film critic Pauline Kael lays out the "simple, good distinction that all art is entertainment but not all entertainment is art."[2] Some cat videos may rise to the level of art, and some are even made by artists (see Cory Arcangel's mashup of cats playing Arnold Schoenberg's op. 11, for starters), but all cat videos are not art, nor are they meant to be. Cat videos, as a phenomenon, are "fundamentally amateur," as critic Mark Greif once described most of the content on YouTube.[3] They are entertainment in the vein of burlesque and talent shows and *America's Funniest Home Videos*. They are good old-fashioned spectacle.

<p style="text-align:center">2</p>

Spectacles are one of the best forms of distraction we have. Ideally, an encounter with a work of art makes you think—it challenges you or causes you to feel so overwhelmingly that you're compelled to figure out why. A spectacle, on the other hand, seeks to envelop, and in doing so invites you to dial down your brain. As Walter Benjamin once put it, "Distraction and

concentration form polar opposites which may be stated as follows: A man who concentrates before a work of art is absorbed by it.... In contrast, the distracted mass absorbs the work of art."[4]

Benjamin uses the work of art as his example, but why bother with it today when we have so many ready-made modes of distraction? If I'm in the mood to make an effort, I'll watch the Antonioni film that's been languishing in its bright-red Netflix envelope atop my DVD player for three months. If I want to unwind after nine exhausting hours of work, I'll watch cat videos. YouTube has done art a favor in freeing it from the need to quickly gratify.

Distraction isn't new; it seems safe to assume that as long as we've had to work, we've sought—and found a way to achieve—distraction. In 1926, critic and theorist Siegfried Kracauer published an essay called "Cult of Distraction," examining the grand movie palaces of Berlin. The all-encompassing shows there, which featured live performers and orchestras in addition to film screenings, "raise distraction to the level of culture," Kracauer writes. "They are aimed at the *masses*."[5]

Germany at the time was carrying out its first experiment with democracy. Censorship had been lifted, and journalism and photography were booming—illustrated magazines littered Berlin. Sound film was becoming a phenomenon; thanks in part to the failing economy, so was Nazism. Kracauer saw distraction as deeply political, tied to industrial capitalism and the plight of the worker. "Critics chide Berliners for being *addicted to distraction*, but this is a petit bourgeois reproach," he writes. "The form of free-time busy-ness necessarily corresponds to the form of business."[6]

Although Kracauer was critical of the picture palaces and the way they manufactured distraction, he also saw potential for a meaningful kind of distraction that would not be "an end in itself" but rather "a reflection of the uncontrolled anarchy of our world."[7] He urged the theaters to "aim radically toward a kind of distraction that exposes disintegration instead of masking it." Unfortunately, he didn't specify what that would look like. I have trouble envisioning it myself, though if it exists at all—a twenty-first-century anarchist circus?—I suspect it lives in Bushwick, Brooklyn.

If Berliners in the thirties were addicted to distraction, it's distressing to think what we must be today. YouTube is a black hole of amusement—it defines distraction. The danger is that it's extremely difficult to get sick of the site; when you're done with cat videos, you can watch an entire movie

(in twelve parts), and when that's over, search for clips from TV shows you watched as a kid. YouTube is a system lacking a meaningful shape. There are no categories, no sophisticated search functions; there's only a simple bar with a magnifying glass icon and a recommendation algorithm that attempts to drag you into its depths as it processes your user history.

But the other, perhaps more profound danger of YouTube is its easy availability: It represents the diffusion of the spectacle. We no longer need to get dressed and pay money at the nearest picture palace in order to dissolve into mindlessness. Virtual escape is constantly within our reach—even at work, where we often need it most.

"It is the opposite of dialogue," theorist Guy Debord writes of the spectacle. "It is the sun which never sets over the empire of modern passivity."[8] When we watch cat videos alone in our rooms, when we give ourselves over to the infinite diversion of YouTube, we are disengaging from the world and all of its problems.

Could something be said for this aloneness, this separation from the crowd? YouTube may have diffused the spectacle, but it's also liberated it from the teeming, swelling masses. We're no longer the club-wielding mob of *Metropolis*, tearing down the machine that gives us life and death. By ourselves, at least theoretically, we might have more time to think—provided we can look away from our computers long enough to do so.

3

If YouTube separates us, the Internet Cat Video Festival brings us back together. That's part of its brilliance. Benjamin identifies the aura as an artwork's "authenticity," "the authority of the object" generated from its unique existence in time and space.[9] Grainy, homemade YouTube videos, videos of our cats furiously chasing bottle caps down the hall, are not made to be singular. They are all reproduction and no aura.

CatVidFest introduces uniqueness where there was none; it brings an element of ritual to this free-floating, diffuse spectacle (which is likely why many people who work at the Walker Art Center are uncomfortable with it). It gives us a reason to gather. A 17,000-person grandstand is the picture palace of the twenty-first century, and we, as Kracauer writes, are the "community of worshippers."[10]

"The spectacle is not a collection of images, but a social relation among people, mediated by images,"[11] said Debord, and if you can get past his supremely pessimistic view of the whole thing, there is an edifying truth in this. The spectacle may depoliticize us, it may numb us to the pain, but it also unites us. In 2015, we may need that more than ever.

I didn't know what to expect when I made my way to Minneapolis that summer, and from there to the State Fair, and from there to the Grandstand. I was excited and curious about CatVidFest, but also guarded. I knew there'd be a level of fandom I could neither muster nor understand. I didn't dare admit I'd never seen a Lil BUB video before. I wasn't wearing cat clothing because I didn't own any. I hadn't even paid the ten dollars for my ticket (I was a guest of the Walker).

But there was something strangely marvelous in how, once we walked through those metal gates, we became a community. A bizarre one with exceptionally weak ties? Yes. But a community still—and one that really, really wanted to watch cat videos. In public. Together. To the point where, as the preshow dragged on with mediocre jokes and awkward interactions, the audience lost its patience and started chanting, "Cats! Cats! Cats!"

When the videos finally rolled, they looked different on the enormous screen. Not like works of art—no, some looked pretty shitty—but somehow more compelling. I felt an anticipation watching them, the kind of euphoria you get from experiencing synchronous emotions with a crowd. The glee is different when you know eleven thousand people are feeling it too. It expands.

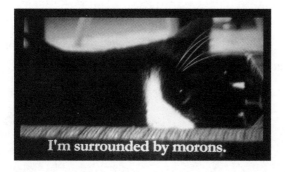

4

The glee died and the confusion set in on the following day, which I spent at the Walker. Following CatVidFest, the museum was hosting a book

signing, the guests of which were Grumpy Cat, Lil BUB, and Will Braden, the filmmaker behind *Henri, le Chat Noir*. The canary-yellow sign announcing the event in the museum's Cargill Lounge literally listed Braden along with two cats—one of whom lacks opposable thumbs, neither of whom could be expected to sign anything.

But that wasn't the strangest part. The strangest part was how, after the line of fans snaked into formation near the signing desk (on which Grumpy Cat lazed in a plush pet bed), it stretched down a corridor, around a corner, and down *another* hallway. At the end of that hallway was another lobby space and another table, where a number of humans—among them Charlie Schmidt, the progenitor of Keyboard Cat; Chris Torres, the creator of Nyan Cat; and Maddie Kelly, the voice behind the "Kittens Inspired by Kittens" video—sat, also ready to sign books; Torres would even draw you a free sketch, if you asked. No one was waiting to approach them.

Cats are not, of course, the first animals to be celebrities. Modern American culture has had its share of famous creatures, from Lassie and Rin Tin Tin to Mr. Ed and Punxsutawney Phil. But cats, so often written off as aloof and high minded, are having their moment. And its shape mirrors that of our wider celebrity culture.

There was a time you had to be talented and do something culturally notable (act, play music or sports) to attain the status of a celebrity. The advent of reality TV in the nineties severely lowered those stakes; suddenly exposure was the whole game. All you had to do was allow yourself to be filmed while going about your life—maybe make an inflammatory statement or two—and you could become famous. The internet, and in large part YouTube, has intensified this phenomenon, allowing people to become recognized around the world simply for making really good hair care tutorials.

Similarly, many of today's celebrity cats aren't known for playing a pet on a sitcom or performing improbably heroic feats; they're famous for being themselves. We love Maru because he happens to be a chubby cat obsessed with getting into boxes; Grumpy Cat cracks us up because of his permanently scowling face. We live in an age not just of the celebrity cat—which would be notable by itself—but of the *reality* celebrity cat. This is undeniably weird.

Some people hypothesize that our obsession with celebrities stems from our simultaneous closeness to (we're all human) and distance from (they're rich and talented and untouchable) them; within this formula, the proliferation of human reality stars makes a certain amount of sense—it narrows the gap to offer us a more attainable vision of fame. But why on earth does this carry over to celebrity cats? How did we get from *The Real World* to the Grumppuccino?

5

Our relationship with animals is long, deep seated, and complex, but what seems to carry consistently across the millennia is an attitude of reverence. The ancient Egyptians venerated cats; cows are an important symbol in Hindu scripture. In critic John Berger's telling, "Animals first entered the imagination as messengers and promises."[12] Think of all the folktales and fables that use animals as a path to knowledge and wisdom.[13]

In the modern world, Berger says, our relationship with "animals of the mind" (as opposed to of the flesh, i.e., meat) manifests in two ways: as family and as spectacle.[14] We keep, in other words, both our pets and our zoos (as well as our cartoon characters). In both cases, although we confine the animals, we cherish them.

Cat videos mark an intriguing combination of the two categories: we make spectacles of our pets. Here the reverence is twofold, both subjective and objective: *Isn't my kitty the cutest you've ever seen ever?* and *This cat has incredible prowess (even if she's only using it to decimate a pile of leaves)*. Our own animals become our beloved entertainers.

A good many cat videos are predicated on the tension that their subjects are both like us and not—that cats seem sometimes to be so human and at other times so foreign. It's a similar dichotomy to the one we play out with celebrities. This view involves a healthy dose of anthropomorphism, but also a certain acceptance of our own animal nature. "The pet *completes* him," Berger writes. "The pet offers its owner a mirror to a part that is otherwise never reflected."[15] We've subjugated the animals, but we know that we still need them. We clean up their shit, but we remain in awe. The ancient Egyptians built statues; we make videos.

<div align="center">6</div>

Then again, let's consider the primary ways in which we interact with animals in the twenty-first century: factory farming and then killing them for meat, placing them in captivity for our entertainment and examination, driving them nearly to extinction and then building "refuges" for them. In most cases, we have stripped the animals of their autonomy, bent them to our will, and in doing so, trivialized them nearly to the point of irrelevance. It may seem on the surface as though we still revere them, but in truth we no longer respect them. How else to explain videos in which cats are made to balance oranges on their heads or wear shark costumes for our amusement?

O.K., you say, but those are only *some* cat videos. In others, people simply record their pets asleep or at play, marveling at how wondrous they are; surely these display a genuine appreciation and affection. On an individual level, sure, but as a society, the keeping of pets at all indicates how

we really feel about animals: We accept them only on our terms, as extensions of ourselves. We impose our values on them because we think they're unworthy—or incapable—of their own. "In particular, our sentimentality toward animals is a sure sign of the disdain in which we hold them," philosopher Jean Baudrillard once wrote. "It is in proportion to being relegated to irresponsibility, to the inhuman, that the animal becomes worthy of the human ritual of affection and protection."[16]

Cat videos are perhaps the most literal and obvious manifestation of this sentimentality. Heartwarming, laughter-inducing, completely ridiculous, and nothing else, they are a painful visualization of how far cats have fallen: from sacred subject to empty spectacle.

<div align="center">7</div>

Up until the turn of the twenty-first century, the cultural products most readily available for consumption were those produced by the culture industry: mass-marketed books, Hollywood blockbusters, TV sitcoms and dramas. The internet changed that by opening up a new, semiblank space for the creation of things: webpages, journals and blogs, artworks, videos. The process wasn't all that different from what we'd been doing for centuries, but when it moved online, it went public. And going public offered new possibilities for interaction and community.

As it turns out, we're not only fascinated by celebrities; we're fascinated by each other (and ourselves). "What YouTube tells us, hit after millionth hit, is that we like watching *amateurs*," Mark Greif writes in his essay "WETUBE." "We like to see them perform, whatever the performance may be."[17] The uniqueness of YouTube is that it allows us to *create our own spectacle*—which changes the character of the distraction we seek.

Writing together in 1944, philosophers and sociologists Max Horkheimer and Theodor Adorno laid bare the machinations of the culture industry in a relentless essay (titled "The Culture Industry: Enlightenment as Mass Deception," in case their position was unclear). Their take—in line with Kracauer's but harsher—is that the culture industry functions as an arm of industrial capitalism that feeds spectacle to the masses in order to keep them distracted and in line. "Entertainment is the prolongation of work under late capitalism. It is sought by those who want to escape the

mechanized labor process so that they can cope with it again," the pair write. "Entertainment fosters the resignation which seeks to forget itself in entertainment."[18]

This is a familiar idea: the creation of culture from the top down as an instrument of control. But the internet, and in many ways specifically YouTube, has upended it by allowing us to create our own entertainment. The tools of production are no longer amassed only in the hands of the powerful. Anyone with a cell phone or a computer today owns a camera and recording device; anyone can capture herself dancing to or parodying Beyoncé in her living room. The means of distraction are ours.

And importantly, we're not always selling something. In their fluffy, adorable emptiness, cat videos—and videos of other animals and people paying tribute to their favorite pop songs—are a return to Horkheimer and Adorno's idea of "pure amusement": entertainment that has neither an ulterior motive nor a need for meaning. Entertainment that simply is.[19]

<div align="center">8</div>

Or rather, they were. When cat videos first appeared, they held a kind of meaningless promise, just as YouTube and the wider internet seemed to offer utopian possibilities: a blank slate, a way to talk to among ourselves while avoiding the powers that be. But nothing lasts forever.

YouTube was created in 2005 by three people who, quite brilliantly, understood the potential of a video-sharing site.[20] Within a year, it had become hugely popular, and in October of 2006, Google bought the site.[21] Now that it's owned by a monolith, one of the largest companies in the world, YouTube essentially works on two levels: as the silly peer-to-peer site we enjoy using every day, and as a tool in the arsenal of a commercial conglomerate that's been known to breach users' privacy and implement censorship. And the clout of relevant commercial interests should not be underestimated. As Greif writes:

> So YouTube becomes another of these media without a recorded
> history—never mind that long-gone historical television clips
> disappear for copyright reasons as soon as the capital-rich media
> conglomerates discover them—never mind that there are ever

more third-party companies devoted to discovering and rooting out this copyrighted material.[22]

YouTube is not ours because we have it on loan—because it plays by the same rules as the rest of the corporate-controlled world.

What's more, beginning in 2007 (in a limited way, and then more broadly in 2012), Google changed the fundamental nature of YouTube by introducing a "partner program" that allows users to buy into its ad network and make money off of their videos[23] (this is also called the "monetization ecosystem").[24] I don't begrudge anyone that money or the desire for it, but pure amusement this is not.

And so cat videos, which began as a bizarre curiosity in a corner of the internet, have blossomed into a cottage industry of mugs, calendars, books, belts, and coffee drinks. Celebrity cats have agents and get paid to endorse products like pet food. A handful of them seem to make far more money than I do (the *Washington Post*'s high end for Maru's potential annual earnings: $181,600).[25] Videos of cats we don't yet recognize are followed by messages to "check out more of my videos!!" in the hopes that they'll become the next feline stars.

Clips of cats leaping off counters and unraveling entire rolls of toilet paper haven't ceased to be entertaining, but I've felt my good faith quietly slipping away. Cat videos still amuse, but now they're also just one more way for someone to try to sell me something.

9

I am watching a video on YouTube. A cat is wearing a turquoise shark costume, the kind you'd buy for a toddler, while sitting atop an iRobot Roomba, an automated vacuum cleaner that resembles a turntable. The cat and the Roomba follow a small duck over the surface of a tan tiled floor. The Roomba hits a wall, jerks around, and keeps moving; the cat barely flinches. The duck's little feet continue waddling to the monotonous drone, and I begin to laugh. The camera angles change—one moment we're seeing the scene from above, the next we're down on the ground, watching Roomba Cat ride his swiveling ship like a captain on the high seas of suburbia. Soon a dog appears, dressed in a different shark costume

that's much too small, making him look as if he's pouting while wearing an absurd blue beret. The dog joins the others in their mute, meandering malaise until suddenly the Roomba stops, and for a fleeting moment, all of the creatures stand and stare at the camera. Still life with animals and machine.[26] Only one minute and thirty-eight seconds have passed, and tears of laughter have sprung to the corners of my eyes. One minute later, the video is over. I resume writing.

Notes

1. Michael Olson, "Are cat videos art?" *MPR News*, August 28, 2013, http://blogs.mprnews .org/statewide/2013/08/are-cat-videos-art.

2. Pauline Kael, "Trash, Art, and the Movies," in *For Keeps: 30 Years at the Movies* (New York: Plume, 1996), 200–227.

3. Mark Greif, "WETUBE," *Paper Monument #2*, September 2008, http://www.papermonument .com/issue-two-preview/wetube.

4. Walter Benjamin, "The Work of Art in the Age of Mechanical Reproduction," in *Illuminations: Essays and Reflections*, trans. Harry Zohn, ed. Hannah Arendt (New York: Schocken Books, 1969), 217–251.

5. Siegfried Kracauer, "Cult of Distraction," in *The Mass Ornament: Weimar Essays*, trans. ed. Thomas Y. Levin (Cambridge, MA: Harvard University Press, 1995), 323–328.

6. Ibid., p. 325.

7. Ibid., p. 327.

8. Guy Debord, *Society of the Spectacle*, trans. anonymous, rev. ed. (Detroit: Black & Red Books, 1977), sections 13 and 18.

9. Benjamin, "The Work of Art in the Age of Mechanical Reproduction," 217–251.

10. Kracauer, "Cult of Distraction," 323–328.

11. Debord, *Society of the Spectacle*, section 4.

12. John Berger, "Why Look at Animals?" in *Selected Essays* (New York: Vintage International, 2003), 259–273.

13. There are countless examples: from Aesop's "The Hare and the Tortoise" and the tales of Brer Rabbit to E. B. White's *Charlotte's Web*, contemporary movies like *Finding Nemo*, and arguably even George Orwell's *Animal Farm*.

14. Berger, "Why Look at Animals?" 259–273.

15. Ibid., 259–273.

16. Jean Baudrillard, "The Animals: Territory and Metamorphoses," in *Simulacra and Simulation*, trans. Sheila Faria Glaser (Ann Arbor: The University of Michigan Press, 1994), 129–141.

17. Greif, "WETUBE."

18. Max Horkheimer and Theodor W. Adorno, "The Culture Industry: Enlightenment as Mass Deception," in *Media and Cultural Studies: KeyWorks,* eds. Meenakshi Gigi Durham and Douglas M. Kellner, rev. ed. (Malden, MA: Blackwell Publishing, 2006), 41–72.

19. Ibid., 55.

20. John Cloud, "The YouTube Gurus," *TIME,* December 25, 2006, http://content.time.com/time/magazine/article/0,9171,1570795,00.html.

21. Paul R. La Monica, "Google to buy YouTube for $1.65 billion," CNN *Money,* October 9, 2006, http://money.cnn.com/2006/10/09/technology/googleyoutube_deal/index.htm?cnn=yes.

22. Greif, "WETUBE."

23. Shawn Knight, "YouTube now letting anyone monetize their videos through AdSense," *TechSpot,* April 13, 2012, http://www.techspot.com/news/48182-youtube-now-letting-anyone-monetize-their-videos-through-adsense.html.

24. "Earn money with YouTube," *YouTube Creator Academy,* accessed July 1, 2015. https://creatoracademy.withgoogle.com/page/course/earn-money.

25. Caitlin Dewey, "From Grumpy Cat to Maru to Lil Bub, Internet cats are actually serious business," *Washington Post,* June 16, 2014, http://www.washingtonpost.com/news/the-intersect/wp/2014/06/16/from-grumpy-cat-to-maru-to-lil-bub-internet-cats-are-actually-serious-business.

26. "Cat In A Shark Costume Chases A Duck While Riding A Roomba," YouTube video, 2:45, posted by "TexasGirly1979," November 1, 2012, https://www.youtube.com/watch?v=Of2HU3LGdbo.

Photo Credits

Photograph on page 11 (left) used by permission of photographer Linda Koutsky. All other photographs are from the author's personal collection. Photograph on page 11 (right) and page 16 first appeared on Hyperallergic.com.

ALEXIS MADRIGAL

SPARROW THE CAT

MY FIRST OFFICIAL ACT AS A DAD WAS committing our beloved cat to death.

We'd come home from the hospital with our son, O, oxytocin levels redlining. Our cat, Sparrow, lay on the dining room table. He took one sniff at the baby and headed out the door. Four days later, he came home, roughed up and wild looking. After ten minutes in the house, he fled again. When he returned three days later, he had an abscess on his face the size of a walnut. He was angry and wouldn't let any of us touch him.

Never the cuddliest animal, Sparrow had transformed into a snarling, feral beast. My wife, S, didn't want him around anymore. And though I had a hard time admitting it, I didn't either. He was a danger to our offspring, so he had to go. My dad assessed the situation: "He hates your guts now." Sparrow, the star of thousands of photographs and Instagrams and videos, was being dumped unceremoniously on his ass. One lesson you could take from our experience: Don't fuck with new parents. They will cut you.

Perhaps Sparrow might find a new home, I reasoned. He was a gorgeous Maine coon–like mutt. His eyes sparkled with intelligence. His shelter name had been Shadow because he really enjoyed being in the company of humans (if not being held by them).

Of course, he also liked to piss on the couch, the bed, and pretty much anywhere else. He liked to mewl through the night. He shredded furniture—and even our walls. His hair got in everything.

Any honest accounting led to the same tragic conclusion: If he left our home, it was unlikely someone else would take him in. He'd been bounced from two different homes in less than three years. That couldn't bode well.

So, a week into our son's life, a week into my life as a dad, I acquiesced to logic. Yes, we would have to *surrender* him. That was the term they used: *surrender*. And yes, he would probably die as a result.

But first I had to get him to the vet, so they could take care of his face. He hadn't loved the cat carrier before, but in his new state, he fought me full-throat, claws out, teeth bared. I was lucky to escape our encounter with my eyes intact and only minor scrapes.

When I arrived at the cat doctor, I felt the need to confess to someone, anyone, that I needed to have this cat examined, *and* I needed to surrender him. Once I told someone, I figured the wheels of bureaucracy would start turning and, some months later, they'd put him down in an anonymous room out by the refrigerated warehouses and tanneries. It would be horribly sad, terrible, really. But my role would end quickly, like voting for war; I'd hit the first domino, not bring the sledgehammer down myself.

The vet who saw us was young and sweet. I quietly explained our beloved cat was injured and we also needed to surrender him because of irreconcilable differences with our newborn. I may have started crying. She may have looked away. Then the vet may have said they would help me try to find a place that could take him in. It happens with cats.

I arranged for them to board him until we could find a shelter. Afterwards, I went home to my beautiful little nugget, who was so new to the world I still wasn't sure if he could really focus his eyes.

They had to sedate Sparrow before they could even look at his injury. That's how pissed he was. His cry was low and deep, a rumble more than a meow.

This was sixty-eight weeks ago, according to Instagram. The Instagram calendar has no years, no days, only weeks. Without the aid of these other architectures, time flows haphazardly, pooling in these big, arbitrary numbers that say a life is really just weeks stacked on top of each other and compressed into a shape I recognize as a self.

The week—having no physical grounding in our planet turning and tilting in space, rotating around a star—seems like the appropriate unit to convey this measurement. We use the nature we find, then make up the rest.

SPARROW THE CAT

You have to understand that we never meant for this to happen. We are not terrible people. We forewent most travel because of Sparrow. We doted over this cat, spending much of our free time thinking or talking about him. We love cats!

In the early days of our relationship, S lived with a cat named Madison, and he was magical. My recognition of this magic, that this animal was more luckdragon than feline, formed a decent chunk of my romantic résumé. I loved watching S interact with Madison because he brought out theretofore unseen vocal and behavioral registers. Her voice went up at least half an octave as she cheerfully called, "KITT-EN! KITT-EN!" in the most adorable way. Where she could be reserved and intense with humans, cats made her silly and funny. It is important to see the people we love be silly.

And there I go treating a cat as a means to an end. That's probably where we went wrong.

We got Sparrow when we moved back to Oakland from the East Coast, after some rough times. This cat was . . . this cat was our symbol of renewed love. Sure, we got engaged, but the cat was the real commitment: We would be bound by caring for this life. A promise cat.

We saw him in the window of a bird shop on College Avenue, sweet and striped, fluffy. The kind of fluff that's a blur on camera. He had a little white goatee and an *M* between his eyes. We fell in love at first sight.

Now, the shelter had some strict rules about adopting cats. They wanted to make sure you were going to be their *forever home*, which entailed getting a signed note from your landlady if you were a renter.

Well, our landlady had told us we could have a cat, but she liked to travel the country by RV, and she was out of range when we saw the cat. Our cat. We didn't know if she'd get back to us before some other goddamn family took our cat home.

So, we did what logic would dictate: We Photoshopped an e-mail from her one painstaking, nerve-racking afternoon. I cut her header off an e-mail she'd sent us and pasted it into a letter O.K.ing the adoption. It wasn't perfect, and the text printed out way too small for some reason. But we were talking about a perfunctory checklist; it would be enough to pass muster.

When we went to pick him up, the shelter worker seemed to smell our fear. She looked and looked and looked at our paperwork as if she could

sense the digital manipulation. Or maybe she was a witch, and she just knew how it would all end.

Finally, begrudgingly, she released him into our care with a promise that we'd never let him outside, that we'd always love him, and that he'd never have to contend with other pets. That's how we became the owners of Mr. Sparrow Martinez.

I introduced him to the world 152 weeks ago on my Instagram account. He's sitting on the back of the couch, which became his favorite spot, with a foreleg dangling down and his ear hair arrayed like peacock feathers. His nose is the most perfect terra-cotta.

Soon, his toys were everywhere. Two weeks later, I snapped a photo of him stepping out of his teepee. "No, this is not a photo of a kitten stepping out of a cardboard cat teepee," I wrote. And I sort of meant it. This was a photo of the completion of our Pythagorean relationship. My wife and I had schemed and nurtured a new route to each other into being. He was neutral, yet conductive. We could meet at Sparrow and know we were safe. He was like home base in our game of tag.

Six weeks later, I wrote, "I am never Instagramming anything or anyone except for Sparrow Martinez. For obvious reasons." I changed my bio on the site to "Mostly pictures of my cat" and really stuck to that brand promise for the next eighty weeks or so.

I loved the way his ears would go back as he kissed my fingers. I loved the way his tail curled around his little feet when he was waiting patiently for something. I loved the way his fluff fanned out in irregular swirls and waves when he fell asleep on his back. I loved how he liked jumping into boxes and bags, the smell of his big, squishy paw pads.

I even loved that he demanded to go outside because I thought it showed character. This was a cat you could not keep inside. At first, we would go with him and try to prevent him from getting hurt. The only time he ever fell was when I tried to help him out of a tree after he'd gotten himself stuck chasing a squirrel. After that, I let him find his own way and he was fine.

The first thing I did after leaving the vet was to call my father and tell him I'd committed my first act of dadhood. Not that committing your animals

to death is the sole province of fathers, but it was in my family. My dad is a genuine animal lover. We got the best dog ever—my childhood friend, Tiny—because my dad pulled two big, nasty dogs off her father, just barely saving his life. His owners, sweet Russian immigrants who lived down the road, brought the tiny puppy to us the minute she was weaned. She was probably my dad's best friend until she had to be put down because benign tumors were making it difficult for her to breathe. My dad, knowing I was in Istanbul, called me anyway. I answered the phone at a fancy restaurant in Beyoğlu on the last night of my vacation. After I couldn't stop crying, I had to leave.

It must have been much worse for my dad. Any time an animal of ours got sick or infirm, he would not avert his eyes and harden his heart, leaving the pet to die alone. He'd take the animal to the vet and hold it as it left its mortal coil, always willing to make an emotional sacrifice to comfort an animal in need. It is one of the things I respect most about him.

So I called him and told him the sad story about how I was going to have to give up my cat. My dad was practical. You have to do it, he said. You can't have the mother of your son worried about that kind of threat in her house. It's bad juju. Being parents of a newborn is tough enough without some cat side-eyeing your baby and your wife side-eyeing the cat.

It made me feel better to know he didn't think I was some monster. But I still felt as if I was wearing emotional chainmail that day. It probably didn't help that I was coming down from the multiday high of witnessing a new life enter the world; that should not be underestimated. But still, deep down I believed we were not doing right by this animal we had sworn to protect. We were as fraudulent as that Photoshopped e-mail from our landlady.

Not two days before our son arrived on the scene, I'd Instagrammed the cat chilling on our dining room table, just as we'd later find him after coming home from the hospital. The love is still there in the photo. I shot him low, so his big paws and legs looked even bigger and longer. He has the most self-satisfied expression on his face—*This* is my dining room table. Pass the scotch.

And then there was nothing. We didn't love him anymore, and he hated us. He had been cut out of our emotional circuit.

As we prepared for another long night with our son, who lay swaddled and slotted between rolled-up towels like a 7-Eleven hot dog, my phone rang. It was my dad. He had talked with my mom, and they'd decided they could take in Sparrow. He could live in the garage with the other cats their children had dumped on them, free to hunt and play and live a carefree country life as long as he managed to survive. I promised to buy pet insurance in case he needed vet visits, and within five minutes, we had it worked out. We'd send Sparrow on a special Delta flight, and my dad would leave work to grab him and take him to paradise.

Sparrow would not die. He would not be condemned to live out his days under fluorescent lighting until the moment a blue-gloved hand reached into his cage and administered the chemicals. He would live and die free, stalking mice and dodging coyotes until his appointed hour.

I was so happy I stumbled into the bedroom where the baby was attached to his mama. I said, "Yes! There is a way!" But S, she still worried. She never wanted to see the cat again. She didn't think she could bear the guilt over how we'd stopped loving him. What would we do at Christmas when we saw him again?

But that *was* the sleepless nights and hormones talking. She soon agreed to the plan, and we made a reservation for Sparrow to fly.

There was only one problem: There were no direct pet cargo flights from San Francisco to Portland. He'd have to route through L.A. or Salt Lake City, and, unfortunately, a high-pressure system had settled over the vast American West, and it was going to be too hot on the tarmac in those cities for Sparrow to fly at a normal hour. He'd have to fly really early so that he wouldn't get roasted in the plane.

So, I set out one morning from our house at 4:30 a.m. with Sparrow in the passenger seat and the BBC World Service on the radio. We went over the new eastern span of the Bay Bridge, my first trip across its geometrical precision, and on to a parking lot at a random Delta office on a frontage road somewhere near the airport. Sparrow did not stop meowing for the entire ride. Even as we sat in the parking lot awaiting the 5:00 a.m. opening, he did not let me forget about his presence. I explained to him

in plain English exactly what was going to happen. Our cat-lady neighbor believes that even though cats cannot speak, they can understand; for once, I decided to agree with her.

Inside, the office had the feel of a twenty-four-hour diner. There was an all-female Delta staff, kerchiefs in place, highlighted hair tied up in various configurations. The customers, myself excepted, were all fishermen there to ship live seafood across the country. These people all knew each other, in a manner of speaking, and there was a friendly lack of efficiency to their interactions. It was, after all, the kind of morning hour that really belongs to the night, and it was easy to believe in this stubby little building out by the airfield that no one else was awake. Why rush when it was just us in purgatory?

Through it all, Sparrow meowed on. He didn't stop meowing, not even after they weighed his crate, took him into a back room, and eventually knee-shouldered him onto a conveyor belt. The sound never went away; it just diminished and diminished. He was still meowing when my father picked him up in Portland.

For a few days, everything was wonderful. We'd purged the cat from our lives. My dad reported he was doing great and eating well. The baby had begun to sort of smile, or make smile-like mouth movements. I still had six weeks of paternity leave left. And it was warm outside in the real September summer of the Bay.

I was seized from this utopia when the odd Facetime ring began to emanate from my phone. Facetime? Unannounced Facetime? Who would want to video chat with me at this moment?

The image resolved—it was my dad, and he clearly was not at home. He's never been all that good at pointing the phone in the right direction while videochatting, so he was at the bottom of the frame, a generous patch of yellow wall behind him. He looked a little green, and I couldn't tell if it was the horrible lighting or if he was sick. That thought made the next obvious: he was in a hospital.

"Oh hey," he said, "just a little question. I'm fine, I'm fine. But has Sparrow gotten a rabies vaccination?"

As it turned out, the goddamn cat had bitten him on his first day on my parents' property. The intervening week, my dad's hand had gotten progressively more infected, despite a heavy dose of oral antibiotics. He was now at a clinic getting IV antibiotics pumped through his system.

"And if the antibiotics don't work?" I asked.

My dad drew a little air circle around the nasty infection between his thumb and forefinger. "They'll have to do a little cutting," he said. Through it all, he was nonplussed. But he did want to know about that rabies vaccine.

As it turned out, Sparrow had been vaccinated for rabies. My father did not die, nor did they have to cut his hand apart. And that, to date, is the only time Sparrow ever attacked my dad. The father can pay for the sins of the son, it turns out.

Sparrow, for his part, is now built like a fur tank. S and I see him at Christmas, and it is as awkward as if he were our ex-husband. He says hello, does the bare minimum, minimizes contact. He's nearly feral at this point, but in a generally friendly way.

As for us, all we have left of him is a particularly furry era of Instagram and that cat teepee, which our kid loves to park his toys in. I changed my bio eventually. It now reads, "Mostly pictures of my son."

ANDER
MONSON

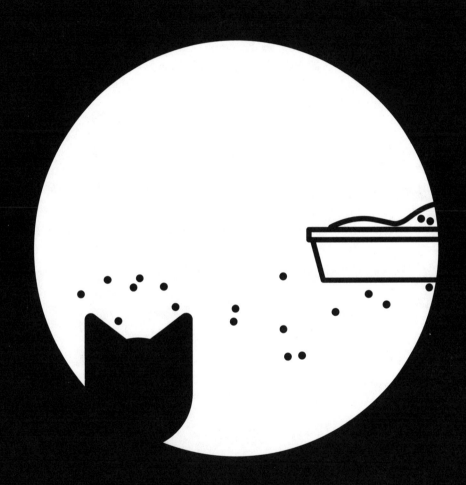

THE INTERNET IS A
CAT VIDEO LIBRARY

Maybe all mail, even email, is a secular faith that a Reader exists on The Other Side.

—Albert Goldbarth, "To the Munger Station"

1

From 10:00 a.m. to 3:00 p.m. on Saturdays and Sundays, you may check out an animal for a week from the Sulphur Creek Nature Center's Small Animal Lending Library, part of the Hayward Area Recreation & Park District in California's Bay Area. It's one of the few of its ilk, and probably the only animal lending library currently extant. No, they inform you when you ask, you can't renew your guinea pigs, hamsters, mice, or rats. For twenty dollars, you may "find out about the responsibilities and enjoyment of having a pet—feeding, cleaning, grooming, handling, and exercising—without the long-term expense and commitment of purchasing an animal."

2

Isn't long-term commitment what we want a pet for? Don't we want an amiable ghost to haunt our house, a beast to sop up our care and desires and prove itself a companion for more than just the week? Don't we want a creature with enough there there to address as "who," not as "that"? Isn't what we want connection? I don't think a week will cut it, but it's a start.

3

The director doesn't know exactly how or when the library originated, but it's not the first. Several popped up in midcentury America, including one run by the Wisconsin Humane Society and one in Sacramento, created by John Ripley Forbes and made famous by an article in *Life*. It lent blackbirds, magpies, rabbits, rats, hamsters, mice, turtles, lizards, snakes, and porcupines, just to name a few. Skunks too.

4

"A child's response to any living thing is emotional," said Forbes. Let's remember that. It's harder to ignore a purring cat, even a boring one, than it is to slip a dull book back on the shelf. Blame Forbes for that midcentury boom in lending animals. Though conservation was his life's work, it often manifested itself in animal lending libraries and "nature museums." His thought: get living things into kids' hands and watch them come alive. And so they did.

5

Because it's a small-animal lending library, it's easier to disregard the creepy equation at its heart. Do we believe animals are ours to lend? Are they here for us, to instruct or entertain, to do with as we will? What does it say that animal lending libraries don't lend dogs or cats or horses or chimpanzees, animals with longer lives and more complicated brains? It's not just logistics that get in the way. Evidently we believe hamsters suffer less and get less attached, that they're less likely to mind being lent or moved, to have a theory of mind—that they are less there, less potentially themselves—than, say, cats. Thus it doesn't bother us to reduce them to the equivalent of a book, something to be lent and returned without much thought to the preferences of the beast. I'll be straight with you: I believe this too. I'm not just saying it to troll you here. Yet I find myself uneasily weighing the relative disposability—or lendability—of different animals. If there is a line between the lendable and not, where you locate it is in part a matter of your own comfort with ethical ambiguity.

Even if we are not dog enthusiasts, for most of us, dogs are not disposable, though when my neighbors' hound yowls out its apostrophe to the night, I wish they were. Dog lovers love each other's dogs. They want to talk to others who love their dogs. They want to socialize their dogs. They want to socialize with others who want to socialize with the sort of people who want to socialize their dogs. To accomplish this, dog lovers congregate at the dog park, where their animals cavort and check each other out, as do the humans, if with less obvious sniffing. But where do cat lovers go to connect? Cats do not relish opportunities to meet new, strange animals, even if their caretakers might want to prick their own lonelinesses with a pin of shared light. Thus Scott Stulen, Internet Cat Video Festival producer, theorizes, "The internet is a cat park." So instead of going out, we go to YouTube to check out videos of cats and check out each other in the comments sections.

I don't use the idiom "check out" idly. Or, like most idioms, at first I use it idly, but then, thinking about it, I get excited at its permutations. It can refer to acquiring a circulating something from a library or assessing a potential sexual or intellectual partner. It can also mean to leave, say, a hospital, or life itself. Yet it accrues more meaning: to seek out and investigate a phenomenon, like a trending cat video a friend mentioned in passing. And on top of that, it also means to absent your brain from an irritating pastime (such as disambiguating idioms). You can start to see connections, right? Each of these instances involves some sort of circulation, a departure from a place or train of thought (we won't even get into disambiguating "train of thought"), an entrance into another state.

Asterisk: Some cats do like to circulate. I think here of Three, my neighbor's unimaginatively named three-legged cat, and how he would jauntily make his rounds about the neighborhood, collecting food and affection at

each stop. He was a good-natured, well-fed animal who just died this year. Now he's only here in the hall of memory.

<div align="center">9</div>

Most cats do not want to be lent or circulated, but posting a video's not so hard. It's really an exchange without losing anything (except perhaps your self-respect): I have a cat. It does something fun. You evidently want to see a cat doing fun things. I post a video. You watch the video. You have fun. You experience an emotional response. In this you are again like a child (a rare pleasure, this kind of occasional disarming). Maybe it's enough that you laugh out loud and show or send it to a friend. The database registers your click and the span of your attention and punctuates your interest with commercials. The view count goes up. If it goes up enough, I may try to monetize your interest. With each view our territory, such as it is, expands. My cat treads through your bedroom digitally. The cat itself is not aware of this.

<div align="center">10</div>

Does putting our cats online constitute a loan? Do we retain our clips? Will they or can they be taken from us or returned? Who owns these things: maker, viewer, or intermediary? YouTube says you do own your clip, and while you retain most of your rights, by posting it you grant YouTube non-exclusive rights to do with it whatever it wishes in perpetuity. You still own it, but you no longer retain exclusive control. The medium takes control. We all should know by now that sharing on the internet invites the readers' participation with or without our say-so in the matter: My sharing courts your remix, not just your clicks. YouTube doesn't let you download clips, but there are ways around that for those of us who would want to keep these things. (Does anyone download and maintain a library of cat videos? If so, drop me a note; I'd love to talk with you.)

Likewise, there's no need to return these clips when we're done with them. They are disposable—or maybe we never acquired them. At most we acquired an emotional experience and a memory of them. We might think they'll always be here. And some won't leave us anyway.

Let's look at the famous Nyan Cat, a lesson in exhaustion: An official selection of the 2014 Internet Cat Video Festival, Nyan Cat is a looped, 8-bit, Pop Tart-bodied, animated cat flying through space, trailing rainbows while an inane sample from a Japanese song plays. It goes on and on and on repeat; inane doesn't cover it—add an *s*, and you're maybe halfway there. Its charm is its reverse: a perversity, it exists to irritate. Conversely, its popularity is immense. The website nyan.cat (and just to hijack this sentence for a little while, nyan.cat hijacks the domain suffix .cat, designed to help spread the Catalan culture and language. Eliding the two, when I load the .cat domain's registration page, Google Translate renders its first instruction from Catalan to English as "register a cat"—which in a way is what we do when we post our pet to YouTube: We check our cat into the database; now he is no longer only ours) tracks how long you can tolerate Nyan Cat's numbing song without incurring vertigo.

I'd suggest you check it out, but I can't recommend the experience. It gets intense real fast. Still, for this anthology—for science—I tried super hard. After several attempts, I must report that I can't make it past 334 seconds without an intense feeling of having wasted my life. As if to acknowledge the pointlessness of your achievement, the website offers, "Tweet your record!" Sir, I will not. First, I'll barf.

Calling it a "record" or an "achievement" mocks the trend of gamifying every little thing in our culture. It's pretty funny, actually.

Watching cat videos is different than watching cats or petting cats or trying to pet recalcitrants who would nip your hand instead. It's the least immersive interaction you can have with a cat. Like nostalgia or consuming porn, it's not an interaction at all, but a kind of loop: it plugs you back into your own predictable desire.

Watching cat videos with other people is an interaction . . . barely. I consider it a nadir of the culture, which already has a lot of nadirs. (Perhaps, writer, you do not understand what nadir means?) When I am drinking at their homes, my friends insist on queuing up cat videos on their screens. I can't take it. They know I can't. I have to turn away. They coo and ohh and troll me gleefully, extolling the virtues of these cute pets and their sounds. My irritation rises with a flush. It's like the doldrums of the after-dinner conversation in which we find ourselves recounting the antics of our pets: We're exhausted; we're not connecting; we're talking to ourselves about ourselves. We might as well go home alone, our buzzes gone.

I'm not proud of this response. I'm not even sure I understand it. Even when I see it coming, I can't seem to stop it. At the least it's adolescent, this too-cool-for-schoolness with which I'm filled, this resistance to digital cuteness. It's not as if I don't enjoy watching other stupid things. But cute only allows for two responses: aww or irritation. Does my resistance mean I want to insulate myself from feeling? Maybe watching cat videos with ten thousand other people in a fairground or a field somehow would invert it, like doing anything with ten thousand other people in a fairground or a field does.

Like a crowd, the internet preserves and amplifies a buzz: We watch because others do, because we saw it somewhere or were told, because it was forwarded or linked to us, because we are susceptible to listicles. But leaving our houses and assembling by the thousands to attend the Internet Cat Video Festival shows another kind of faith. In what, I wonder: Pointlessness? Loneliness? Irony? Nostalgia? Are we opting out of our desires to biggie-size our glittering consumer-grade culture and fit it in our mouths by watching videos of cats instead? Are we engaging our shared mania for mania? Do we just join a loop? Or is it where the meta and the aww can meet and coexist, where we might meet someone to coexist with?

When we watch cats onscreen, we always watch the past. (And we watch our-selves watching the past, etcetera ad nauseam.) Do we understand that this library—that any library—is mostly ghosts? Many of these cats by now have died, starting with the historical ones (the stars of Thomas Edison's 1894 video "Boxing Cats," almost certainly the first cat video). Only a handful of these animals will outlive their lives as memes. Marty, Nyan Cat's inspira-tion, died in 2012. Fatso, better known as Keyboard Cat (made famous for his undignified puppet pantomime), died in 1987, before the internet was born. In our way, we venerate his name. Colonel Meow died in 2014 before turn-ing three. Dewey Readmore Books, the famous library cat of Spencer, Iowa, died in 2006. His obituary ran in more than 250 newspapers. Even Three died, though he was not obituarized (except in this parenthetical: RIP, Three; you were a good-ass cat, video or no video). If we have video, we can still hold them on our screens. They will perform their tricks on command. Like smoke, their view count will rise forever. Watch and rinse, repeat.

The most famous internet cat at the present moment (always that caveat when we speak of celebrity) hails from two and a half hours north of me in Arizona. Grumpy Cat, nom de guerre of the inexplicably misspelled "Tardar Sauce" (at the time of her birth, her owner was reportedly wait-ressing at Red Lobster), lives in Morristown, Arizona, not in fact a town, as the name implies, but a "census-designated place" ("a concentration of population identified by the United States Census Bureau for statistical purposes" to get all Wikisexy on your asses). Indeed, there's little there in Morristown if you were to drive through. Space and cacti. While Tabatha Bundesen surely owns her pet (and has indeed registered the trademarks and made the requisite deals and monetized and merchandized and got an agent and so forth, to pin the point up on the wall and lance it like a boil), we have come to own her too, we viewers, we fans.

A cat video without a viewer is no cat video at all. Only via our viral likes does it earn status. Posting a cat video becomes a religious act, or at least one of belief. Fans feel so strongly about Grumpy Cat that they

turn out in the thousands to see her (yes, she is a she) "in person" at her appearances at festivals. How else to raise the ante on our friends who've only seen her videos? Is it any different than the pleasure we take from attending concerts in the flesh? By so doing, we can bore our friends at later dates. We were there. We may not count for much, but we were there.

Grumpy Cat's fans can be intense. They want to interface with Grumpy Cat so powerfully and constantly that Tabatha has had to stipulate that she will only be available a maximum of once a week for photo sessions. Of course you'll have to pay.

<div align="center">19</div>

If you want to interface with animals and won't settle for a video and don't have a pet of your own and don't live close enough to the Small Animal Lending Library to use its services, you do have other options. You can think about adopting: In Tucson, make your way to the Humane Society, or to the Hermitage No-Kill Cat Shelter, or to the rows of cages at PetSmart that I find to be so singularly depressing that I close my eyes when I pass them (I can't handle their collected neediness). The only thing that could be sadder than woeful pets in cages looking hopefully at me— dreaming of "a forever home," to put it in the parlance of the times—is if my visit could be soundtracked, like the commercials featuring one-eyed dogs for the ASPCA, by Sarah McLachlan songs.

Here: just take all the money.

<div align="center">20</div>

Actually, as all the earbudded or ostentatiously headphoned teens know, you can soundtrack, and thus better tolerate, any experience.

<div align="center">21</div>

Today I want to get my hands on an animal, and mine will not comply. So I head to the obvious place, the International Wildlife Museum (IWM) on Tucson's western edge. It's so often confused for the Desert Museum

that when you walk in, a placard on the desk reads THIS IS NOT THE DESERT MUSEUM. It's just a museum in the desert.

It turns out the IWM is closing in an hour for the rest of the week to host the Fifteenth Annual Predator Masters convention. The Predator Masters are a bunch of internet friends ("the largest predator hunting organization in the world ... almost 50,000 members worldwide") who specialize in hunting predatory animals (and whose planned competitive coyote-shooting excursion for the weekend has generated quite a lot of local controversy, for obvious reasons). As I arrived, a disgruntled-looking group was being given directions to the Desert Museum, which, you may want to know, is about twenty minutes west if you keep following the road (and if you visit Tucson, you really need to go there first; it's spectacular, and they have animals).

The IWM also has animals, even if they are pretty much all dead. Aside from the docents, eleven tourists, and the staff setting up for the Predator Masters, the only living things I saw were in three small terrariums in the entry room, which was otherwise devoted exclusively to glass cases of mounted moths and pinned beetles. They housed, respectively, a giant desert hairy scorpion, a bunch of Madagascar hissing cockroaches, and an Arizona blond tarantula, none of which moved at all while I was there. As if to reassure us they really were alive, the signs read LIVE ANIMALS: PLEASE DO NOT TAP THE GLASS. Though I did not do so, I definitely wanted to tap the glass.

Everything past that point is dead or fake and mostly taxidermied with various levels of skill and realism. First there's an odd display of animal skeletons: pigeon, rat, mink, cat, and barn owl. Then a box of furs that you can stroke. Here's a whole room of horns and tusks and hair and teeth, some of which you can touch. And whoa, here's a huge taxidermied ostrich positioned against an impressionistic painted panorama. I was excited to encounter an array of animals frozen in battle-posture dioramas: Leopard v. Chacma Baboon, Wolves v. Caribou, Unsporting Gray Wolf v. Eastern Gray Squirrel, Bobcat v. Overmatched California Quail, Mountain Lion v. North American Pronghorn, Two Honey Badgers v. Cobra, Really Irritated Ostrich v. Hyena Stealing Ostrich's Egg. This seemed like a great use of taxidermy.

I petted all of this that I could reach. All of it felt cold.

It's not actually clear what you're allowed to touch and what you're not. I figure if it's not under glass and you can reach the carcass without falling over the barrier, it's fair game to give it a stroke. So I ran my fingers through a wild boar's coarse fir and the shellacked feathers of a bunch of large birds. I handled the leg of a bear and a lot of tusks and horns. I mean, I touched what used to be those things. Well, a tusk is still a tusk, but touching the leg of a dead bear isn't touching a bear.

There is also an amusing room filled with arrays of poop that terminates with an image of an elephant's rear captioned The End.

The centerpiece of the museum—and the room least invested in education and most obviously resembling an elaborate trophy case—is McElroy Hall, named after the museum's founder, who accumulated many of the trophies. Enter it and be amazed, or perhaps nauseated. The whole room is stuffed (ha ha) with animals, dead and mounted, some whole, or if not, at least we have their heads. (Personally I might prefer a whole room of mounted hooves or eyes, which at least would feel a little more honest in their synecdoche.) I found it overwhelming. If the rest of the museum verges on parody, this room goes way beyond it into crazy colonial white guy, camo-face-painted, patriarchal farce. I only managed to stay in there longer than 334 seconds because I was counting parts of animals so you'd believe that I was there. On the far wall, for instance, there are 109 deer or other horned mammals in rows that disintegrate into bunches of animal heads toward the right end. Quite a few them are babies. I mean, they were fawns. Now they're the equivalent of suburban lawns, glossy and well groomed and saying something about conformity.

Stunned by muchness, you may want to sit. Happily, in front of the wall of deer, there's an alligator you can sit on to catch your breath. Behind you, there are ten great stuffed cats in macho poses, if animals can be said to have a macho pose. Three dudes in camouflage clustered around a really big moose, unsure of whether—or how—to touch it. A woman exclaimed at the number of taxidermied fawns: "Oh they're all so small! Why they're just babies!"

I checked out for a while after that.

As a coda, the last room you walk through is devoted to three fabricated prehistoric animals: the always-awesome woolly mammoth and the giant deer (which is exactly what it sounds like: a huge deer with an improbably large, twelve-foot antler span). Last, there is a wall-sized painting of a car-sized beaver inset with a case exhibiting a "modern beaver skull." The exhibit is captioned,

accurately, "Giant Beaver." Though there is no way to pet the giant beaver, still I ran my hands along the wall. I had hoped to raid the gift shop for a complete catalog of the museum's holdings, but it was decimated, or maybe all packed up to host the Predator Masters, with nothing to offer except for snacks. No one was there to take my money for a large Arizona Iced Tea, so I just stuffed it in my bag. Where might have once been educational materials and books and shirts and toys for kids, or even toy guns, there was now just open space, half-arranged chairs, and some sort-of-realistic savannah sounds leaking in from the room next door.

22

I felt very empty after. Not empty in the Nyan Cat way or the watching-cat-videos-with-friends way, but for sure a boggled emptiness. I wasn't sure how to process the experience. For a wildlife museum, that sure was a lot of death. Was it real? Did it constitute an animal encounter? I wasn't sure if I was having an emotional response or an existential one. I thought of writing a letter to Albert Goldbarth.

I watched a couple cat videos on my laptop to clean my emotional palate and drank my Arizona Iced Tea. It was sure sugary; it went down easy. Maybe this is what these things are for.

23

On my return, I did track down my three cats and give them each a serious petting.

24

A placeless place, Morristown, population 227, was called Vulture Siding until 1897, then Hot Springs Junction for a while, then eventually just Morristown, after its first inhabitant. Its only notable resident (who cannot, I note, be counted in its population) and by far its most popular attraction is Grumpy Cat. Her owners have spoken publicly about taxidermy as an option when she dies.

CARL WILSON

EAST OF INTENTION: CAT, CAMERA, MUSIC

IN "CHAT ÉCOUTANT LA MUSIQUE" ("Cat Listening to Music"), a two-minute, fifty-five-second video posted to YouTube on December 21, 2010, a black, white, and gray tabby sprawls across the keyboard of a Yamaha DX7.[1] He sleeps and stirs, seeming to enjoy the pellucid, lapping notes and chords of a piece of piano music playing in the room. We watch the cat's paws depress the keys soundlessly when he arches and stretches. We notice his ears perk and twitch. When the music briefly intensifies, he raises his head and glares fiercely into the middle distance; then, as the tune eases off the tension, he slackens and settles down again.

The camera pulls back into a wider view, and it becomes clear that the room is someone's music studio, with a reel-to-reel recorder, mixer, and other equipment. We see two photos behind the Yahama, one of a lithe Asian profile (one YouTube commenter claims it is the writer Yukio Mishima, but when I enlarge the image it is too blurry to be sure, though it could be a book cover rather than a photo standing alone), the other of a cat, likely this cat, but head-on, alert, and erect. In some shots, we see sheet music next to the photographed cat's face, as if it were reading the notation. When the camera cuts to an image of the stereo playing the music, the cat's face is reflected in its plastic cover—either the cat in the picture or the cat in the room; again, it's hard to decipher. Back in animate time, the cat rises, rotates, returns to dozing. Blackout. Credits.

Those credits, like the grain of the clip overall, are soft and filmic, not in the crisp digital relief of the standard YouTube video. For this is not exactly a YouTube video, except insofar as everything on YouTube (and so nearly everything ever) is a YouTube video, at least until it becomes a

staticky void box containing a copyright infringement notice. It is "Chat écoutant la musique," a portion of the ten-minute 1990 triptych *Bestiaire*[2] by the renowned French filmmaker Chris Marker (1921–2012), along with the much less tranquil "An Owl Is an Owl Is an Owl"[3] and "Zoo Piece,"[4] which were also part of a larger installation Marker showed in the Centre Pompidou in the early 1990s. As a home movie of a pet going about its endearing daily ways—Guillaume-en-Egypte, Marker's own cat, was a frequent cameo player in his filmic essays, his letters, and other places, a kind of alter ego for its reclusive maker—"Cat Listening to Music" seems native to YouTube, avant le YouTube.

However, it would not be remotely accurate to call it "the first cat video," as one of the commenters on the post does. The feline became an object of filmic fixation nearly with its invention; witness Thomas Edison's 1894 short "Boxing Cats."[5] Even earlier, if you count Eadweard Muybridge's flipbook-style photographic animal locomotion studies in the 1880s, though his galloping horses tend to eclipse in glory his trotting and jumping cats. Cinematic cats are nowhere near as ubiquitous as movie dogs, which are much more amenable to instruction, able to clown or command pathos on cue. But film has remained a fairly cat-friendly precinct, particularly in its more eccentric redoubts. Cartoon stand-ins such as Tom, Sylvester, surrealist Felix, or the bawdy Fritz aside, cats take the lead in Disney-DayGlo fare such as *That Darn Cat!* or *The Cat from Outer Space* or the charmingly fantastical and technically mind-blowing feline-POV feature *The Three Lives of Thomasina* (1964). They are potent spiritual familiars in modernist and postmodernist experimental films, not only those of Marker but of Alexander Hammid and Maya Deren, Carolee Schneemann, Joyce Wieland, Donald Richie, and many others. In the aesthetic alleyways in between those poles, cats seem especially fond of going astray in early sixties Greenwich Village—whether slipping from Audrey Hepburn's embrace in *Breakfast at Tiffany's* or wriggling out of Oscar Isaac's grasp only to return uncannily (but not at all uncattily) again and again in *Inside Llewyn Davis.*

These two are both movies of a certain anxious blankness that disclose their warmest sentiments through music: Do the eyes of Holly Golightly's cat, that "poor slob without a name," well up the way many viewers' do when its similarly self-insufficient mistress serenades it as her

"huckleberry friend" in Mancini and Mercer's "Moon River"? Does Llewyn Davis's ginger tomcat Ulysses (whom he inadvertently abducts from his uptown patrons the Gorfeins, or perhaps more existentially, Ulysses abducts him) feel his spine tingle or his hackles rise at Davis's early sixties folk-revival stylings? Maybe its predatory instincts are triggered by his three renditions of "Fare Thee Well (Dink's Song)," in which he dreams of having "wings like Noah's dove" and pledges that "sure as the birds flying high above / life ain't worth living without the one you love." Or perhaps the cat identifies with the many lives the song has lived. They doubtless begin long before the day in 1904 that songcatcher John Lomax heard it from an African American woman named Dink scrubbing clothes at a migrant camp on the banks of Texas's Brazos River, on through Libby Holman's 1942 Decca torch-blues recording with Josh White, the early sixties versions by Dave Van Ronk (the Coen brothers' main model for the Llewyn Davis character) and Bob Dylan (the usurper doing his territorial pissing on Van Ronk's folkie throne), and folk-rock martyr Jeff Buckley's eleven-minute live excursion in 1993. Of course, you can hear most of these versions on YouTube.[6]

The transmigratory soul of the cat may be a dusty legend, but it sets the catnip fiend up as an apt mascot for the many-sided cycle of musical reincarnation that is the "folk process." Likewise, behind the scenes of *Inside Llewyn Davis* itself, Ulysses is not one orange tabby but many, each specializing by temperament in one of the behaviors required for different scenes: being held without protest, running across window ledges and down fire escapes, loitering around indifferently. Beings of mythic multiplicity, but creatures of singular willfulness—no wonder cats' respectable record at the movie house pales before their domination of that individualistic yet sequentially near-infinite twenty-first-century folkloric cultural commons, YouTube.

While Marker's "Cat Listening to Music" is far from being the first cat video, it may claim a special place as a predecessor of a prominent subset of the form: YouTube videos of musical cats, whether as performers or music appreciators. With his perch atop the DX7, Guillaume-en-Egypte strikes a 2015 observer as a more transcendent godparent of "Keyboard Cat," the famous YouTube clip starring a cat named Fatso whose paws are manipulated by owner Charlie Schmidt to play a jaunty tune on an

electronic organ, originally posted in June 2007.[7] It went viral a couple of years later as "Play Him Off, Keyboard Cat," a rickrollesque[8] meme, a punchline to any given internet "fail" that signaled its object being given the equivalent of the vaudeville "hook," or the orchestra "playing off" a dull speaker at the Academy Awards.[9] As of this writing, the original Fatso video has more than thirty-nine million YouTube hits and countless parodies and variations.

Yet even that genealogy is deceptive, as is so often true in the recursive cultural geometry of YouTube: Schmidt's video actually predates Marker's film, having been made in 1984 as part of Schmidt's own art practice. It simply went all but unseen until its YouTube heyday, by which time Fatso himself was twenty years dead. And save for their juxtaposition of cat and keyboard, Schmidt's and Marker's works seem like complete opposites—Schmidt's a gonzo act of blatant comical manipulation; Marker's a serene laissez-faire study in cinéma vérité. What intrigues me, though, is how valid that distinction really is. That's the issue that feels as if it has broader consequences for the manifold encounters between human, cat, image, movement, music, world.

As you watch "Cat Listening to Music," even on a first viewing, you begin to wonder about the correspondence between what you see and what you hear. Verisimilitude is established by repeated shots of the dynamic monitor on the CD player lighting up in synch with the volume of the music, but is there any guarantee that the flickers of Guillaume's ears and paws, his rousing and relaxing, actually match the music we hear in the same way? The cat may not be listening to the music at all. It could be dubbed in later, edited together. Certainly it does not matter that the cat is lying on a keyboard, which is not activated and not generating any of the sounds in the film.

The musical piece in question, Impresiones intimas: no. 5, Pájaro triste ("Intimate Impressions: no. 5, Sad Bird"), by the French Catalan Federico Mompou (1893–1987), is itself so elusive that no matter when or how Guillaume fidgets or flinches, it can be perceived as choreography. Mompou's works have been called "silent music" or, by writer-pianist Stephen Hough, a "music of evaporation."[10] It is music with such a light relationship to intentionality, such a disinterest in direction, that only its harmonic coherence convinces us that it was composed at all rather than

played at random, as if by a cat walking across a keyboard. (Mompou's scores were published without key or time signatures or bar lines.) It shares its sparseness with the works of Erik Satie, but with less austerity, more fluffy reverie; it is music that seems to aspire to slip from its maker's control gently and fuzzily, not as declaratively as the aleatory or ambient works of John Cage or the environmentally attuned music of Pauline Oliveros or R. Murray Schafer. Pardon the conceit, but you might say that it is a more domesticated arm of that approach, its musical freedom the limited kind available to a pet rather than a beast in the wild.

Marker is reported to have said of recording Guillaume-en-Egypte for "Cat Listening to Music" that "He was fond of Ravel (any cat is) but he had a special crush on Mompou. That day (a beautiful sunny day, I remember) I placed Volume I of the complete *Mompou by Mompou* on the CD player to please him …"[11] It is up to the audience to accept Marker's account verbatim, or to suspect him of projecting or altogether fibbing. Is he, like Schmidt, using his cat as an instrument for his art, or naively fantasizing what's passing through the cat's alien mind and senses, or discovering some genuine moment of cross-species accord, even transcendence? "We do not have cats, cats have us," he once said. "Cats are our Gods, the most expansive and approachable of Gods, it goes without saying."[12] It is a pretty thought, if rather a lax one for the rigorous intellectual who made *La Jetée* and *Sans Soleil*, as if he'd been caught in a moment of idle cat fancy, the mood of a person procrastinating by surfing kitten videos online. Yet Guillaume and other cats pop up throughout his work, not only as "personal mascot," writes Nora M. Alter, but also as political totems for the elements of reality that are objectified rather than honored in their fullness. His 1977 essay-film about the failures of European and Latin American socialist movements in the sixties and seventies has the Lewis Carroll–esque title in English *A Grin Without a Cat*, signifying, as David Sterritt writes, the promise and propaganda of revolution without the better world that is supposed to be attached.[13] If "Cat Listening to Music" makes us doubt whether its idyll is one that happened exactly as its title says, perhaps it is designed to foster such radical doubt. The photo of the cat, the cat's reflection in the CD player, the cat in the film frame—all three doppelgangers shimmering like Mompou's music for a whisper in time, three-plus minutes before

their own triple Cheshire-ian vanishing act ... or shuffled into the virtual endless diversity of a YouTube playlist.

The lineage of feline music, whether in music history or contemporary upload, similarly circles around impulses of mockery and manipulation (whether cruel or affectionate) versus the cat as autonomous spirit or agent. The nefarious apex of the former tendency is the (one hopes) apocryphal story of the Katzenklavier, the "cat piano" or "cat organ," described and/or pictured in seventeenth-century works such as Athanasius Kircher's *Musurgia Universalis* and Gaspar Schott's *Magia Naturalis*. A device to entertain a royal court, the Katzenklavier reputedly involved a passel of cats and kittens confined to small boxes in order of the pitch of their voices, such that their tails were pulled or stabbed by nails when a keyboard was struck, producing (writes Kircher) "a melody of meows that became more vigorous as the cats became more desperate. Who could not help but laugh at such music?"[14] My optimism that the cat piano never existed is based not in faith in humanity's kindness to animals, but in the improbability of being able to tune the instrument with the remotest accuracy.

In its grisly biomechanics, the Katzenklavier's nearest contemporary equivalent might be the "half cat, half machine" that Dutch artist Bart Jansen constructed out of the corpse of his pet cat Orville after it was struck and killed by a car—the radio-controlled flying drone "Orvillecopter" he showed at an Amsterdam art festival in 2012.[15] It can be witnessed in action on YouTube, (un)naturally, scored to the tune of Wagner's "Ride of the Valkyries."[16]

More benignly, living cats have been turned into musical devices online through the application of electronic tone-controlling sensors,[17] or more crudely, as in 2011's "Cat Slap Joy Division," only amplifying pickups.[18] In the 2014 "Cat Band" meme on Instagram, cats were held and "strummed" or otherwise used by their owners as air guitars and other mimed instruments to backing tracks.[19] British sound sculptor Henry Dagg created the most direct yet humane descendant to the Katzenklavier by assembling a "keyboard" made up of squeaky-toy stuffed animals, on which he can perform songs like "Somewhere Over the Rainbow" with some precision.[20] Dagg's invention drew media attention in 2010 after he played it at a garden party to the great amusement of Charles, Prince of

Wales. Apparently Buckingham Palace's devoted conservationist wasn't aware of the bloodier tales of aristocratic pleasures past.[21]

But the most characteristic route to the cat organ on YouTube is through editing software—taking samples of live cats' actual meows (often, one suspects, tonally modified as well) and stringing them into melodies. They remind me of Rossini and Ravel's "cat duets," in which two vocalists belt out tunes in meows, a game small children and advertising jingle writers have never been able to resist either. The most famous family of "singing" cats in this form is the five-cat Musashi group out of Japan, which had a YouTube hit with its chorale on "Jingle Bells" in 2007.[22]

As Gideon Lewis-Kraus reports in his 2012 *Wired* magazine feature, "In Search of the Living, Purring, Singing Heart of the Online Cat-Industrial Complex," the Musashis were subsequently signed by a promotional company to do mobile-phone content and TV theme songs. They were paid in fish, but their owners ate it.[23]

Even setting concerns over catsploitation aside, these creations are briefly diverting but, like the many, many edited-together videos of cats "dancing" to music, they suffer from a lack of spontaneity and an overlay of anthropomorphization. Cats are used to make the kind of music humans know and like. The YouTube cat videos I appreciate most feature cats seemingly acting out of their own cat nature, either out of the blue or in reaction to a given situation—like the presence of a box or another animal or perhaps a metronome.[24] What kind of "music," then, do cats make of their own accord?

There's a musical tradition related to that question as well, and it is known as "Kitten on the Keys."[25] Written by novelty pianist Zez Confrey in 1921, the tail of the ragtime era, the song emulated the multioctave movements of a cat's paws across a piano and became a massive hit. Of course, its simulation remained well within the period's tolerance for discord and made sure to include repeated melodic hooks.[26] But in the YouTube age—coming after all the fury and noise of twentieth-century music—our ears are more accommodating, and one of the biggest feline stars is Nora the Piano Cat.[27] Nora, the pet of a New Jersey piano teacher, took enthusiastically to plunking random notes on the keyboard alongside her owner. Nora's YouTube videos have racked up more than six million hits and inspired the Lithuanian conductor and composer Mindaugas Piečaitis to

write his *CATcerto*, an orchestral piece setting Nora's improvisations and featuring her on video as a "soloist"—that performance has been viewed more than five million times on YouTube.[28] Going to further extremes and making an even more coy joke about modernism, high and low culture, animal magnetism, and human systematization, the New York video artist Cory Arcangel collected "every video of a cat playing piano I could find on YouTube"—some 170—and edited them into an impressive facsimile of Arnold Schoenberg's 1909 op. 11 *Drei Klavierstücke ("Three Piano Pieces")*, often considered the first case of outright atonality in Western music history.[29]

In some ways Piečaitis's composition annoys me as a recuperation of Nora's chaotic, instinctive fumblings back into a human academic container, of an opaque soundscape to an intelligible one—something her piano-teacher owner also does in several of her videos by attempting to "duet" with her, now expanded to a more oppressively professional and epic scale. Yet it also strikes me that it could be read from the opposite end: as divulging the inside joke of human music, that all the pretensions and theory of Western musical history is but an elaborate version of walking on the keys, of enjoying sound for the sake of sound, in which meaning is neither inherent nor mandatory. Perhaps it all is whimsical play with no other kind of necessity.

Arcangel's Meow-enberg videos seem to heighten that thought to the nth degree, abandoning even the supposed dignity of fun and "originality" in Piečaitis's concerto, and instead requiring a titanic and absurd amount of labor only to produce a slightly shoddy version of a work that already existed. It partakes of course of the remix culture of YouTube, but even more so it recalled for me the visual and literary work that Sianne Ngai has labeled "the stuplime"—stupefying heaps of mundane material or circular or fragmentary language from which the rational mind flees in a reverse mechanism from the Kantian sublime, such as in the loop-de-looping sentences of Gertrude Stein's *The Making of Americans*. These are cases of Chaplinesque or Pee-wee Herman–like slapstick, Beckettian collapse, which in their stubborn failure and persistence in apparent triviality resist grander designs and systems, almost a "work to rule" campaign against social reality. Keyboard Cat is trying to play them off, but they refuse to go, refuse to stop; they cannot stay, they do not budge.

The mass of cat videos on YouTube has that aggregate effect, but in a way, so can any given YouTube cat video that is not too gimmicky or overcalculated. Human perception seems programmed to test our theories of mind on everything we see, to determine whether we attribute deliberation and consciousness to it or chalk it up to blind nonagency. A child skips a stone across the water, but a hill does not roll a rock down in its slope. A dog seems to act with dogged intention even when its aims are idiotic, yet it is maddeningly difficult to demarcate when a cat is doing something consciously or instinctively accidentally. The gaze rebounds, in each second flipping the answer back and forth, as if we were staring at one of those diagrams that in one glance seems to be a rabbit and in the next a duck, alternating rapidly and deteriorating as the signal continues—mind, no mind, mind, no mind, duck, rabbit, duck, rabbit, duckrabbit, ducrabbit, durabbit, drabbit, drrbit, drrbbt, drrbbt, drrbbt. It's a tickle in the brain that breaks down into nonsense, and so we laugh, and our theories of mind buckle for a moment. This is the Zen of the cat video, and indeed the Zen of cats. As Lewis-Kraus's *Wired* article reports, studies have shown that we're not imagining it—cats do indeed pay more attention to people the less we want them to, and vice versa, as if they were not so much independent as somehow bent on correcting an error in our ways.

And perhaps music itself is as abstract, separated, and autonomous a force from humanity as the domestic cat—dependent on us for its existence and yet indifferent to us at the same time. Perhaps not even dependent on us for existence, except by circular reasoning that defines music as human-made. (Which could be rebutted with a new Zen koan: "Animals cannot make music. Humans are animals. Therefore humans cannot make music.") So how can we pretend to track these entities' interactions? Certainly peering into the window of Marker's "Cat Listening to Music," much less the more straightforward and funnier "Cat Watching Slayer" (April 19, 2011; 1.34 million views to date),[30] I am left wondering, in the words of a 2013 *Smithsonian* news headline, "Why Do We Care Whether Animals Appreciate Our Art?"[31] They already have their anthills and mating dances and nests.

According to the most recent science, it's sounding like Marker and all those on the internet who imagine their cats are particularly fond of Ravel or Mozart or Johnny Cash are likely to deluding themselves. A

February 2015 paper in the journal *Applied Animal Behavior* concludes that "Cats prefer species-appropriate music," sounds that suggest animal calls, suckling, or purring, often at higher octaves than those to humans' tastes.[32] Close observation suggested they were indifferent or averse to most man-made music by comparison.[33]

And frankly I share their inclinations, at least when I am disposed to think about cats. The Montreal-based artist Sherwin Sullivan Tjia released an iTunes album in 2009 titled *The E-Z Purr* by "The Virtual Cat," which looped together twenty-nine tracks of cat purrs of three or four minutes in length, and it is one of the more soothing evening listens in my collection, an easy slide into a sublime stupor.[34] Of course there are multiple YouTube purring videos available as well. It's the very nonperformativity of these clips that reassures me. I think back to the popularity in the sixties and seventies of recordings of whale song—it's often forgotten that those tracks would be played on FM radio and that the 1979 *National Geographic* edition of *Songs of the Humpback Whale* holds the record for the largest single pressing of any album in history, with ten million copies.[35] Along with the first views of Earth from space and other phenomena of that moment, it was key to the first nurturing of ecological consciousness, to the cause of marine conservation, and to a nascent awareness of unexplored complexities in animal intelligence, perhaps even culture. These are questions we still haven't answered today, even as the situation of the global environment has become more fraught and perilous. It concerns me that so much of the rich storehouse of YouTube animal videos assures us of the convenience and compatibility of animal life with contemporary human habits, rather than the depths of its strangeness, alike to us perhaps only in its basic needs, no matter how intimately and domestically we live together. A cat is not our instrument nor our audience. I have heard the cats singing each to each, and I know they do not sing to me, at least without some serious interference.

In *A Grin Without a Cat*, Chris Marker succinctly remarked, "A cat is never on the side of power." The ever-cycling attractions of YouTube can make it hard to remember where that power plugs in, to trace it to its source—call it Google, or call it the hand up Keyboard Cat's shirt, the courtier at the seat of the Katzenklavier. But sure as the birds flying high above, life ain't worth living without the ones you love. Try singing the old

songs again, out of Egypt, east of intention. Sing it different—you don't have to spell it out in the key of C. The cats won't care. They never do.

Notes

1. "Cat Listening to Music—Chris Marker," YouTube video, 2:55, from Chris Marker's collection *Bestiaire* (1990), posted by "Juan Soto," December 21, 2010, https://www.youtube.com /watch?v=MrEHvDdEPrI.

2. "Bestiaire," *Electronic Arts Intermix*, accessed July 1, 2015, http://www.eai.org/title .htm?id=2373.

3. "an owl is an owl is an owl by Chris Marker," YouTube video, 3:22, posted by "Juan Soto," December 21, 2010, https://www.youtube.com/watch?v=l_j4HE4-8zI.

4. "Zoo Piece—Chris Marker," YouTube video, 2:48, posted by "Juan Soto," December 21, 2010, https://www.youtube.com/watch?v=v8ZIfU4XGeU.

5. "Thomas Edison—1984 Boxing cats," YouTube video, 0:22, posted by "Seamus McGoon," June 5, 2007, https://www.youtube.com/watch?v=k52pLvVmmkU.

6. Jesse David Fox, "8 Unique versions of *Inside Llewyn Davis*'s 'Fare Thee Well (Dink's Song),'" *Vulture*, December 23, 2013, http://www.vulture.com/2013/12/inside-llewyn-davis-fare-thee-well-history.html.

7. "Charlie Schmidt's Keyboard Cat!—THE ORIGINAL," YouTube video, 0:54, posted by "chuckieart," June 7, 2007, https://www.youtube.com/watch?v=J---aiyznGQ.

8. "Rickrolling," *Wikipedia*, last modified June 9, 2015, https://en.wikipedia.org/wiki /Rickrolling.

9. Jamie Dubs, "Keyboard Cat," *Know Your Meme*, last modified March 7, 2014, http:// knowyourmeme.com/memes/keyboard-cat.

10. Stephen Hough, "Mompou: Piano Music," *Stephen Hough*, accessed July 1, 2015, http:// www.stephenhough.com/writings/album-notes/mompou-piano-music.php.

11. "Bestiaire."

12. Nora M. Alter, *Chris Marker* (Chicago: University of Illinois Press, 2006), 1.

13. David Sterritt, "Grin Without a Cat," *Cineaste Magazine*, July 31, 2011.

14. Chelsea Nichols, "Katzenklavier: The Cat Piano," *The Museum of Ridiculously Interesting Things*, February 12, 2013, http://ridiculouslyinteresting.com/2013/02/12/katzenklavier-the -cat-piano.

15. Michael Sheridan, "Dutch artist turns dead cat into remote-controlled helicopter, dubbed 'Orvillecopter,'" *New York Daily News*, June 4, 2012, http://www.nydailynews.com/news /world/dutch-artist-turns-dead-cat-remote-controlled-helicopter-dubbed-orvillecopter -article-1.1089478.

16. "OrvilleCopter," YouTube video, 1:20, posted by "PewnyPL," June 5, 2012, https:// www.youtube.com/watch?v=rypyjJCtGBE.

17. "Objects Hacked To Make Music: Sushi, Cats & More," YouTube video, 2:43, posted by "fourclops ::)," October 26, 2014, https://www.youtube.com/watch?v=hyffiay16Zk.

18. "Cat Slap Joy Division," YouTube video, 1:57, posted by "Dennis Logan," October 19, 2011, https://www.youtube.com/watch?v=IJlualhdUpc.

19. Molly Horan, "Cat Band," *Know Your Meme*, last modified April 14, 2014, http://knowyourmeme.com/memes/cat-band.

20. "Guy Plays A Cat Organ (BBC)," YouTube video, 1:53, posted by "TheFMPvideos," March 4, 2012, https://www.youtube.com/watch?v=GxEHi6Mlzmk.

21. "Cats Funny: Prince of Wails: Cat Organ Cracks Up Charles," YouTube video, 1:06, posted by "video2fone6," September 11, 2010, https://www.youtube.com/watch?v=FbeSHgDfRw0.

22. "Musashi's Xmas song," YouTube video, 1:11, posted by "musaeri's channel," December 7, 2007, https://www.youtube.com/watch?v=tpHy2lQimYA.

23. Gideon Lewis-Kraus, "In Search of the Living, Purring, Singing Heart of the Online Cat-Industrial Complex," *Wired*, August 31, 2012, http://www.wired.com/2012/08/ff_cats.

24. "Snooky and the Metronome," YouTube video, 1:45, posted by "Peter J Stavroulakis," January 11, 2011, https://www.youtube.com/watch?v=kdmd5fenroU.

25. An image of the cover art is available at http://www.perfessorbill.com/covers/kotksong .jpg.

26. "Zez Confrey—Kitten on the Keys (audio + sheet music)," YouTube video, 2:37, posted by "thenameisgsarci," April 9, 2013, http://www.youtube.com/watch?v=pEEI8dj78Ow. An orchestrated 1922 recording of this piece is available at http://www.loc.gov/jukebox/recordings/detail /id/8816.

27. "Nora's Mews," *Nora the Piano Cat*, last modified June 1, 2015, http://norathepianocat .com.

28. "CATcerto. ORIGINAL PERFORMANCE. Mindaugas Piecaitis, Nora The Piano Cat," YouTube video, 4:51, posted by "Mindaugas Piecaitis," https://www.youtube.com /watch?v=zeoT66v4EHg.

29. Cory Arcangel, "Drei Klavierstücke op. 11," *Cory Arcangel's Official Portfolio Website and Portal*, 2009, http://www.coryarcangel.com/things-i-made/DreiKlavierstucke.

30. "Cat Watching Slayer," YouTube video, 0:59, posted by "CatWatchingSlayer," https:// www.youtube.com/watch?v=Mx1sN15C5rs.

31. Rose Eveleth, "Why Do We Care Whether Animals Appreciate Our Art?" *Smithsonian Smart News*, February 27, 2013, http://www.smithsonianmag.com/smart-news/why-do-we-care -whether-animals-appreciate-our-art-28894385.

32. Charles T. Snowdon, David Teie, and Megan Savage, "Cats prefer species-appropriate music," *Applied Animal Behaviour Science* 166 (February 20, 2015): 106–111. doi: http://dx.doi .org/10.1016/j.applanim.2015.02.012.

33. "MUSICFORCATS.com," *Teyus Music LLC*, accessed July 1, 2015, http://musicforcats .com/21-listen.htm.

34. *The Virtual Cat!* "The E-Z-Purr," recorded by Sherwin Tjia, September 9, 2009, electronic recording, available on iTunes.

35. David Rothenberg, "Nature's greatest hit: The old and new songs of the humpback whale," *Wire*, September 2014, http://www.thewire.co.uk/in-writing/essays/nature_s -greatest-hit_the-old-and-new-songs-of-the-humpback-whale.

MATTHEA
HARVEY

WALLS DIVIDE
HUMANS AND THEIR
CATS FROM OTHER
HUMANS . . .

Walls Divide Humans and Their Cats from Other Humans, but Cat Videos Are Our Digital Cat Doors, Peepholes into a Great Cross-Species Love

MOST NIGHTS IN SEVENTH GRADE, AFTER walking home with my friend E, I proceed to spend hours on the phone with her, discussing school. We're in the same class, so we've already spent all day together, passing coded and intricately folded notes, analyzing the division of the school cafeteria's ice cream sandwiches, which can be purchased for a quarter. (Best friends get half. Top four get a quarter. After that it's just a lick.) The only problem with our feedback loop of going to school and discussing what's happened at school after school is that E has two cats, and on the phone, she constantly exclaims over them: "Oh, Fluffy just jumped over Muffy," or even more yawn-inspiringly, "Fluffy is so sweet." These are not her cats' real names. I have no idea what their real names were—that's just how little I listen.

Still, I challenge you to find a bigger animal lover. My first word was "dog," and in many photos of me as a small child, I'm holding (sometimes ill advisedly, by the neck) a small dog or cat that I grabbed from a passerby. There's a manic look on my round little face that matches the panic on the face of the previously placid quadruped.

As a child, I never had a dog or cat of my own.[1] At age eight, out of a desperate need for furriness, I proactively advertised my services as a pet sitter. I can still remember copying my pitch over and over with my red Le Pen onto lined index cards, which I then stuck in all my neighbors' screen doors. For a preteen pet sitter, the dogs' charms were obvious. They wagged; they licked; they could be walked past one's crush's house. Bridget, a white Scottie, got a vanilla cookie after lunch, and I usually snuck one too. The cats were pretty with their plumy tails, but they mostly ate their terrible-smelling pâté and then slunk away.

Why did E's telephone cat monologues bore me so? Maybe because I couldn't see what all the fuss was about. I literally couldn't see them.

Some people grow out of their devotion to animals. I did not. During my sophomore year in college, I was given a cockatiel named Ulysses for Valentine's Day. He was thrice confiscated from my room by the super-intendent but eluded permanent capture via a network of bird sympa-thizers in that same dormitory; they fostered him while I vowed to the authorities that I had found him a permanent and legal home. The minute I moved into in an apartment during my senior year of college, I went to an animal shelter and found Wednesday, indisputably the world's greatest kitten. I named her Wednesday for the old English rhyme, "Wednesday's child is full of woe, Thursday's child has far to go . . ." Wednesday was tiny and black, from the tip of her whiskers to her tail. I had recently dyed my hair black, so she matched me and all my clothes. She also arched her spine like an inchworm before she pounced and had a machine-like purr that permeated the very edges of that cold linoleum room. After a call to my landlord and a twenty-five-dollar fee, she was mine.

I'll never forget that first night when it was time to go to sleep. I got into bed and waited to see what Wednesday would do. The absence of words was very loud—we were two creatures who didn't yet know how to communicate. First Wednesday jumped onto the futon (on top of me) and chased her tail, a tiny furry tornado spinning across the quilt. Then she sat, her rump against my head and her paws on my shoulder, and, purring loudly, went to sleep. I lay there and thought, "O.K., that's how it's going to be." I was hers.

I only have a few photos from Wednesday's kittenhood. They're black and white (an artsy phase), but I know that in each one she's wearing a bright pink collar with a bell on it. In one, my roommate Z—her head spontaneously shaved the week before—is on all fours, and Wednesday is resting on her tiny haunches, looking at the camera with kittenish disdain. In another, she's behind the shade in the bathroom window, her body a distorted shadow from some puppet play out of which emerges that famil-iar and loveable head. I've shown these pictures to a total of maybe five people. They're particularly precious because I have so few.

The day I graduated from college, our first-floor apartment was broken in to. Clever thieves—they knew everyone would be at the commencement ceremony, and there would be graduation presents on offer. We returned to our apartment to find it minus two laptop computers, one stereo, and some jewelry. Wednesday was curled up in the sun patch on my roommate's bed in the front room, fast asleep. I couldn't believe they hadn't taken her.

Before videos, photographs; before photographs, poems. My husband Rob started a literary magazine called *jubilat* in 1998. It borrowed its name from a poem by English poet Christopher Smart, *Jubilate Agno*, which was written between 1759 and 1763 while Smart was in St. Luke's Hospital for Lunatics, then the cheaper Mr. Potter's asylum in Bethnal Green. The poem, itself over one thousand lines long, includes a much-excerpted seventy-four-line eulogy for his cat, Jeoffry (from whom he was apparently not separated during his hospitalizations). Jeoffry is perhaps the first cat celebrity, though his celebrity only commenced centuries later in 1939, when the poem was first published. Jeoffry's virtues are extolled in lines such as "For there is nothing sweeter than his peace when at rest, / For there is nothing brisker than his life when in motion" and "For he is good to think on . . ." I literally used to think on Wednesday—I would lay my head on her and dream up poems. She liked to sit on my lap as I typed. And of course "think on" also conjures up the way we project ourselves onto our pets. I remember when I moved to Iowa City for graduate school, Wednesday started pulling her fur out. I'd watch her lick the raw patch (awfully named the Pizza Patch by my then-boyfriend) and think, "She doesn't like it here. We don't like it here."

While in Iowa, I read William Carlos Williams's "Poem (As the cat)" for the first time; in it, I recognized the quality of attention that I brought to my interactions with Wednesday:

> As the cat
> climbed over
> the top of

the jamcloset
first the right
forefoot

carefully
then the hind
stepped down

into the pit of
the empty
flowerpot

Those line breaks perfectly capture the delicacy, precision, and hesitation of a cat as it tries out a treacherous new route. I don't doubt that Williams saw exactly this situation and that he wanted to share his noticing.

Wednesday lived for twenty years, approximately ninety-seven in human years, but still not nearly enough. After Wednesday died, it was as if the furry black magnet at the center of the apartment was gone. We wandered around aimlessly. We were inconsolable. I cried at least four times a day. On someone's recommendation, we started watching the show *My Cat from Hell*. It is hosted by Jackson Galaxy, a tall bald man sleeved in tattoos, who has ever-changing goatee and sideburn patterns, and who is essentially a cat angel.[2] The arc of the show is the same each time: Couples or roommates, never anyone solo (though one pair does thankfully break up between Jackson's visits) send in videos of their problem cats. You will not see *these* videos at festivals or on animal websites. These cats are pissing on outlets, scratching, biting, hissing at, and otherwise attacking their owners or other animals in the house. In a way it was inspiring (though alarming) to see what people will put up with for the sake of their animals. The humans in the pre-visit interviews threaten to leave their partners or refuse to get married if the cat's behavior doesn't improve. Jackson then looks at the video disapprovingly and says, "I'd better get over there," and we cut to B-roll footage of Jackson speeding to the rescue in a pink or blue

Chrysler convertible, a guitar case filled with cat toys in the back (by season three this guitar case is adorned with big green cat eyes).

The not-so-secret secret of the show is that the cats are never at fault—it's the humans. If the cat is attacking the humans, it's almost always the case that the humans aren't playing with the cat, so it starts to not-play hunt them to expend that energy. If a cat is peeing everywhere, it turns out that stray cats are marking the yard, or perhaps there are two cats that don't get along and need to be reintroduced. Here's the sweetest part: Jackson talks to the owners and then goes solo to meet the cat. Jackson curls into a ball and slowly blinks at the cat until it returns the slow blink (this is a technique that works on many cats—they take it as a sign that you're not a threat).[3] Cat videos are a huge part of this show: The participants have to videotape themselves "doing their homework," and on the second visit, Jackson reviews these videos with the humans.

Why did I watch all four seasons of this show in the days and weeks after Wednesday's death? Because the arc is pure wish fulfillment. Start with sad or angry cat, end with happy cat. Sometimes it's a literal ascent: a cat who is hiding in its litter box is played with and given perches around the house; suddenly it becomes a completely different animal—confident, loving, and loved. If only Jackson could have knocked at our door and cured Wednesday of old age and her various illnesses. I want Wednesday back.

In one particularly heart-clawing episode, Jackson meets a couple, Bob and Stephanie, who have been feeding (but not managing to tame) a feral Scottish fold cat called Buddy. Buddy is terrified of people and turns out to have cancer of the jaw (which can't be operated on and taken care of postsurgery unless he gains some level of comfort with humans). Through Jackson's particularly ingenious efforts—Buddy is crazy about chicken, so Jackson marinates two pairs of gloves in a pan of roast chicken and has the couple wear them—Buddy starts to have an actual relationship with the couple. What also emerges is that Stephanie was herself homeless when she first met her husband Bob at the grocery store. Here's Jackson summing up the scenario: "Buddy wandered the neighborhood for years until somebody who also was thrown away at some point in their life said, 'No, this is not going to happen to another being on my watch.'" I challenge you not to cry at that.

We have only four videos of Wednesday. Rob gave me a flip video camera as a birthday present, expressly so that I could take videos of her. She was around fifteen at this point, and we were (prematurely as it turned out) worrying about when she would die. I took four videos of her, which were mundane as all get-out—her walking back and forth on the back of the sofa, that sort of thing—and then I didn't make any more because making the videos made the specter of her death loom larger somehow. These videos are different from the photographs—they're precious because they're so ordinary (what I wouldn't give for four more ordinary moments with her), and I'm not sure we'll ever let anyone watch them, mostly because tears spring to my eyes just thinking of them, but also because their meaning exists between the video and the two people for whom those moments are painfully, permanently gone.

My nephew T, age seven, is very sad about Wednesday's death, and even sadder, I think, for us. In Austria with my sister, he chooses a small glass rabbit with gold ears to cheer me up. He declined a cat: "That would make her think of Wednesday." Rob and I put the glass rabbit with Wednesday's ashes, which sit under a life-size bronze cat given to us by a sculptor friend at our wedding. The next time I see T, he asks about Wednesday's death. "Did you videotape it?" I'm startled and say "No!" a bit too loudly. Then when he asks, "Why?" I say, "Because it would make us too sad," and he seems to understand. His comment is probably prompted half by natural curiosity about death and half by the fact that we document everything these days. Unfortunately, our brains automatically videotape the saddest moments, so there's no need for an actual record. But the happy ones are worth being reminded of.

It's hard to write this essay because love—whether it's interspecies or cross-species—is hard to put into words, and I'm not a naturally confessional writer in any case. I wrote one poem about Wednesday, a truly terrible and

maudlin undergraduate effort titled "Penance," after I had her spayed. More appropriately, I dedicated my children's book *Cecil the Pet Glacier* to her.

If you pay proper attention to any person or animal, you'll find that they're so multifaceted it'll blind you, and it doesn't feel right to write about them partially. How do I sum up a creature who required this many nicknames—Da Pud, Shitty Little Fanghead, Meow Rocket, Inky Minky, Captain Catter, Baby Bunny Biscotti Backfeet—and countless other, forgotten ones? How to explain the excitement when I woke up from a dream in which Wednesday told me, "That sleeping position (where she would fold her paws in my cupped hand and go to sleep next to me) is called 'Bear,' but if your hand is under my stomach, it is called 'White Bear'"? How to describe the glorious smell of her freshly washed fur, the whiff of salmon in her yawn?

Yet writers (and probably most pet owners, or guardians, as Jackson Galaxy calls them) can't help but be noticers. I'm excessively attentive to my husband's facial expressions (poor thing can't even have unspoken thoughts), as was I to Wednesday's postures, purrs, and meows. A week after bringing Wednesday home, I was sitting at the kitchen table with my two roommates. "Does Wednesday look funny to you?" I asked, noting a new expression on her face. My roommates said no. Two minutes later, she slid from the radiator onto the floor. After x-rays, it became clear that she had ingested a large glow-in-the-dark rubber snake from a friend's Halloween Medusa costume. The vet seemed to enjoy this episode: "Nothing to worry about. Just turn off the lights and look in the litter box." I soon spoke fluent Wednesday—I would say "cat" but I don't think they all speak the same language.

My husband and I put shades up in our bedroom. Wednesday came into my office to find me—meowed and walked down the hall, still meowing, looking back over her shoulder until I followed. She then jumped onto the bed where the sun patch should be and meowed again at the drawn shade until I lifted it, allowing sunlight to spill onto the bed, at which point she curled up and went to sleep. Our most complex communication occurred

near the end of her life, when she managed to ask via meowing and head pointing, "Please bring the blanket from the couch in the living room and put it in that sun patch on your study floor; now please lift up a corner, as I would like to nap under there." I might have gotten the two pleases wrong, but I promise you that is exactly what she asked for. She proceeded to take a four-hour nap in that spot—a little lump under a mustardy wool blanket.

I want to be able to communicate as perfectly as possible with my creatures, but it turns out that perhaps I want to communicate about them too. When you have a cat or two kittens (as we do now),[4] they have a relationship with you, not with anyone else, and they're certainly not going to perform it for the pet sitter or for some other stranger who comes over. It's the perfect private relationship. But why wouldn't we want to share this perfection? Thank goodness for Facebook and Instagram and Cute Overload (though I resent that I was an early adoptee and lifelong devotee of the latter, and they have yet to feature my clearly superior felines). They're a gift to cat lovers and introverts everywhere. Yes, we would like to stay inside our apartments on the couch with our cats, but that doesn't preclude our desire for our cats to be admired.

One of the kittens, Meucci Creampuff Starpillow—a skittish seal tortie point snowshoe Siamese (who's also potentially part Ragdoll, according to today's vet visit) has long meowversations with us. She's frightened of most things—shoes, bags, unusually small shoeboxes, the telephone, the vacuum cleaner, and people. When a visitor/intruder appears, she is absent and mute—at most they'll glimpse a pair of pink-and-beige-speckled ears under the bed. Hence the excitement of capturing one of our chats on video. If you had a fairy or an elf who disappeared every time your friends came over, might you not be tempted to videotape said elf as proof? Meucci will never raise her speckled little paws out to you, or sing an operatic version of what truly sounds like the chorus of "Say Something" performed by Christina Aguilera and A Great Big World.[5] You probably won't see our little tuxedo cat, Vamos R2D2 Dangermouse, do her "invisible recliner" move, in which she shifts from standing into a pose that really looks as if she's lounging on a La-Z-boy; experience her "are-you-cute?" move (also called "No-Vamos"), where she chirps and rolls onto her back with all four paws in the air; see one of her ninja fits, where she parkours off the walls of our long hallway; or catch her lifting her excessively large and fluffy tail

up with her paws so that she can properly wash it. But no worries—there's a photo, and we've also captured it on video!

Jackson Galaxy was asked in an interview, "Why are cats so popular on the internet?" This was his response:

> I don't freaking know.... I don't know what the hell is the deal with 'Keyboard Cat.'[6] Do I mind it? Obviously not. It is that way of saying cats are so much more a part of our collective unconscious than we know.[7]

Today, as we wait for the vet to see Meucci, the TV mounted high in the corner is tuned to Animal Planet, which is airing a show called *Cute Cats*. Rob and I watch, laughing at videos we've seen before (the cat hiding in a suitcase who springs out like a jack-in-the-box whenever its owner touches the zipper, only to promptly disappear again) while we try to soothe Meucci by petting her cheeks inside the cat carrier. At some point, I look down from the screen at the scene around us. On another bench is a lady with a giant brown lab and a kitten in a carrier, a couple with a French bulldog, and a man with a big ginger cat. They're smiling at the screen, at each other, and at their animals, exclaiming, "I'd never do that!" over a poor tabby who has been unceremoniously stuffed into a suit and tie. There's a feeling of great unspoken affection swirling around the room as we sit there, animals holding boxes with animals inside them, watching another box on the wall with more animals on it. In loving animals, our simpler, sweeter selves come out. We're reduced to our most generous gerunds: feeding, playing, petting, and loving. We're beings, just being, just so. The world needs more cat videos.

Notes

1. I was not entirely animal deprived. I had a chick who grew into a rooster called Pecky and was pretty promptly eaten by a fox; a series of hamsters called Lizzy, Snowy, Peanut, and Fuzzy; a much-beloved parakeet called Bismarck, who died of a beak disease, for which I blame

the homeopathic vet clinic where I was working at the time; and a parakeet pair, Sonny and Napoleon. At an early age, I also thought I had a pet daddy longlegs (who waited for me outside my school, then flew home with me) and that I was training pill bugs to walk across a little red bridge.

2. It's perhaps no surprise that, like the Dog Whisperer, the Cat Listener (as he bills himself) is male. There's such a stigma about being a cat lady that you can buy the Crazy Cat Lady Action Figure in two versions—each comes with six separate cats in addition to the two on the lady's person. Here's the description of version one: "The G.I. Joes and He-Man action figures of your youth have got nothing on this feline-loving spinster. Why does the neighborhood crazy cat lady deserve such an honor? Well, she may not be able to shoot laser beams from her eyeballs, but you can't get within twenty feet of her without doubling over from the smell of cat doo. Who can argue that stench isn't a superpower? The posable 5 1/4-inch Crazy Cat Lady Action Figure comes with a variety of feline companions and is rocking the telltale flannel jammies and robe ensemble. She makes the perfect gift for all the cat lovers on your shopping list." And version two: "Every town has a Crazy Cat Lady, but it's the rare desk that boasts an articulated Crazy Cat Lady Version 2 Action Figure! This 5 1/4-inch-tall Crazy Cat Lady has a wild look in her eyes and, appropriately enough, comes with six cats, all of whom sport a unique look. Some even share the Crazy Cat Lady's insane eyes! Articulation at the knees, waist, shoulders, and more. This figure is a variant of the Crazy Cat Lady with the pea green outfit." There is even the Crazy Cat Lady Game, "the insane game where collecting a herd of feral felines is a good thing!" Clearly no one wants a crazy cat lady to come to their house, so instead we have Jackson, whose surprisingly masculine (and non–crazy cat lady appearance) is frequently commented on by the show's clients.

3. We learned this technique years before we started watching *My Cat from Hell*, and indeed Rob and I slow-blinked at Wednesday so frequently that we began slow-blinking at one another as a way of saying, "I love you."

4. A year before Wednesday died, my dear friend A (who was once Wednesday for Halloween) texted me a picture of two tiny balls of fluff. She'd found them abandoned in the woodpile next to her cabin in Pennsylvania. They were starving, complete with fleas, ticks, worms, feline herpes, and bronchitis; the shelters were full; and she and her family are allergic. Rob and I debated for a moment and then said, yes, we'd foster them. Five minutes later, without meeting them, we agreed that we'd keep them. Wednesday spent all her time in the bedroom at this point, snoozing on her heated bed, so when we found out that the kittens had herpes, we decided to keep them separate from one another.

5. Yes, I not only love cats, I also watch *The Voice*.

6. In case you're not familiar with Keyboard Cat, he/she faux-plays the piano.

7. Whitney Friedlander, "Jackson Galaxy, the 'Cat Whisperer' of Animal Planet's *My Cat from Hell*," *LA Weekly*, June 14, 2012, http://www.laweekly.com/arts/jackson-galaxy -the-cat-whisperer-of-animal-planets-my-cat-from-hell-2370559.

ELENA
PASSARELLO

JEOFFRY

IN 1938, A YELLOWED FOLIO WAS DISCOVERED in a private English library. In it were fragments of the *Jubilate Agno*, an unpublished work written by Christopher Smart from the confines of an asylum. For most of the 1760s, Smart convalesced in St. Luke's hospital (we think), battling what some called religious mania, others lunacy, still others public drunkenness, and which Smart himself called "my jeopardy."

Before they locked him up, Smart was praying constantly, often knocking on doors or stopping coaches in St. James's Park to find folks to kneel with him. His wife left him; he couldn't keep a job. And the *Jubilate* fragments are very much an extension of that man—its 1,200-odd verses are a ceaseless prayer, written in a language both confounding and exquisite. He makes up words; he plays punny games; he moves through formal concepts involving the alphabet, the books of the Bible, and *hundreds* of animals. But this is not how the *Jubilate* is known to twenty-first-century readers. All anyone really cares about nowadays is the part with the cat.

The seventy-four lines called "My Cat Jeoffry" are often anthologized as the representative excerpt of the *Jubilate*, and they are the seventy-four most loved lines, as well as the most famous. They show Jeoffry the cat weaving in and out of Smart's undefined keep; he catches mice and guards against "the adversary"; he "spraggles," howls, and—of course—praises the lord who made him. Every line of "Jeoffry" begins with "For"—*"For I will consider my Cat Jeoffry.... For he is a mixture of gravity and waggery.... For, tho he cannot fly, he is an excellent clamberer.... For he can creep,"* and so on. Smart praises Jeoffry with an obsessiveness many cat lovers will recognize all too

well. Even if we are not in a padded cell, we know what it means to worship cats without ceasing.

But here's the thing: even the excerpt of this perfect cat poem is incomplete. Seventy-four other lines, each beginning with the word "Let," should be running down the left side of the folio, as is the style of the more intact parts of the *Jubilate*. Those lines should be read alongside the "For" lines contemporary readers know and love. I was so shocked to hear this that I called Smart scholar (Smartian? Smart-y?) Clement Hawes for confirmation. And once confirmed, I got to thinking: what would happen if *I* filled in the gaps myself?

This ridiculous decision requires a small confession. In my life (which mostly consists of me typing in my home office while wearing stretchy pants), I often feel trapped. The trap is one I've made for myself, as a writer and overactive internet-er. But each scroll through Buzzfeed I take, each Wiki-wormhole I fall down, and each deadline I slog through only further drowns me in a ceaseless stream of intangible words. How am I less kept than "Kit" Smart was, really?

Another confession: My cats are not as cool as Jeoffry. They don't catch rats or dance with godly joy. They stick their butts in my face and sneeze in my water glass. My cats are lazy dickwads. And I've found that, in my darkest hours at the keyboard, I turn not to them, but to *virtual* cats. Henri and Keyboard Cat are my Jeoffry: When trapped at my desk, I marvel at them and praise them for their healing powers. Video cats are, for me at least, the closest cats to God.

So, as an ode to theses kitties (and to Kit Smart), I spent a month reading *Jubilate Agno* ceaselessly (O.K., almost ceaselessly). I tried to impersonate Smart's wordplay, his sense of elegy, and his smashing together of the ancient and the new. I wrote seventy-four "Let" lines that talk to Smart's "Fors," like a call and response 250 years in the making.

Jeoffry (Felis catus)
1760

My Cat Jeoffry from Jubilate Agno, Fragment B
(1760)

*68 Let SHEPHATIAH rejoice with the little Owl, which is the
winged Cat. 68 For I am possessed of a cat, surpassing in
beauty, from whom I take
 occasion to bless Almighty God.*

> *—Christopher Smart,* Jubilate Agno, *Fragment B*

695) Let the UNNAMED CAT of Cyprus consider the man in her tomb.

696) Let SEKMET, whose breath made the deserts, uncover the straggled.

697) Let TA-MIU keep the crown prince a-catted till dawn.

698) Let LOMASA, trapped in the doxy net, take pains to skirt his struggles.

699) Let BASTET's temple rise catastrophic.

700) Let GOTOKU-JI's Holy Cat snuff the pilgrim's fire.

701) Let OVINNIK chase ghosts from frenzied SMARTS.

702) Let, after this, all kept menagerie Cats praise tenfold their JEOFFRY!

703) Let the Ocelot give her singular kit for Jeoffry to embrace.

704) Let the Lion sneeze as he did on the Ark and bring forth double Jeoffrys.

705) Let the Panther slumber three days past Jeoffry's rollicking.

706) Let the Wildcat quarter his killing and share it.

707) Let the Jaguar's quintessence refute all the filth.

708) Let the Pard teach Jeoffry six ways of escapement.

709) Let the Catamount hide the bite half a fortnight.

710) Let the Lynx rejoice—up, down, sideways infinitum.

711) Let the Cheetah run Jeoffry nine quick miles from LOGIC.

712) Let the Lion mark him safe with uproarious X.

713) Let, after this, all marbled thinkers keep a good Cat in their books.

714) Let JOHNSON enshrine good HODGE in his study.

715) Let MONTAIGNE cat-sport with VANITY (or does she man-sport with him)?

716) Let JEROME be-saint the Cat who stalks the papers for the murine.

717) Let SCARLATTI give the left-hand line to jaunty PULCINELLA.

718) Let not PANGUR BÀN disappear his kept monk with unseeing.

719) Let RICHLIEU's bed lamps be vouchsafed by LUCIFER and LUDOVIC.

720) Let WALPOLE mourn poor SELIMA, murdered by the house goldfish.

721) Let all kept creatures bask in the light of the one true MAGNIFICAT!

722) Let, after this, Jeoffry rebuff traffic with any suspect stripe.

723) Let his man not be thought mad, though he may show some Tiger teeth.

724) Let Jeoffry not be a May cat (one a-kept by melancholia).

725) Let trouble befall all men who expectorate Cat slander.

726) Let the washerfrau who beats the cat besoak her own damned line.

727) Let HOGARTH's wanton boys, who string up tails, meet the longest sticks.

695 *For I will consider my Cat Jeoffry.*

696 *For he is the servant of the Living God duly and daily serving him.*

697 *For at the first glance of the glory of God in the East he worships in his way.*

698 *For is this done by wreathing his body seven times round with elegant quickness.*

699 *For then he leaps up to catch the musk, which is the blessing of God upon his prayer.*

700 *For he rolls upon prank to work it in.*

701 *For having done duty and received blessing he begins to consider himself.*

702 *For this he performs in ten degrees.*

703 *For first he looks upon his fore-paws to see if they are clean.*

704 *For secondly he kicks up behind to clear away there.*

705 *For thirdly he works it upon stretch with the fore-paws extended.*

706 *For fourthly he sharpens his paws by wood.*

707 *For fifthly he washes himself.*

708 *For sixthly he rolls upon wash.*

709 *For seventhly he fleas himself, that he may not be interrupted upon the beat.*

710 *For eighthly he rubs himself against a post.*

711 *For ninthly he looks up for his instructions.*

712 *For tenthly he goes in quest of food.*

713 *For having consider'd God and himself he will consider his neighbour.*

714 *For if he meets another cat he will kiss her in kindness.*

715 *For when he takes his prey he plays with it to give it chance.*

716 *For one mouse in seven escapes by his dallying.*

717 *For when his day's work is done his business more properly begins.*

718 *For he keeps the Lord's watch in the night against the adversary.*

719 *For he counteracts the powers of darkness by his electrical skin and glaring eyes.*

720 *For he counteracts the Devil, who is death, by brisking about the life.*

721 *For in his morning orisons he loves the sun and the sun loves him.*

722 *For he is of the tribe of Tiger.*

723 *For the Cherub Cat is a term of the Angel Tiger.*

724 *For he has the subtlety and hissing of a serpent, which in goodness he suppresses.*

725 *For he will not do destruction, if he is well-fed, neither will he spit without provocation.*

726 *For he purrs in thankfulness, when God tells him he's a good Cat.*

727 *For he is an instrument for the children to learn benevolence upon.*

728) Let Jeoffry not catch curses on a Scottish belvedere.

729) Let J not shield the soldier-breast at the gates to Pelisium.

730) Let the SMART brood always keep Cats as kin, for each KIT must be kept.

731) Let, after this, all hounds bring Jeoffry their continental praise.

732) Let a hound be known as the mirror of man, but a Cat? A learnéd external.

733) Let JEOFFRY reflect neither God nor man, but a set of doggéd peculiars.

734) Let Jeoffry be given the hound bone, the tooth, and the scratch.

735) Let the stale words of hounds heretoforely be doggerel.

736) Let Jeoffry tread forward with four sure feet.

737) Let his gait be unchecked and also undogly.

738) Let it be known, after this, that the space between God and SMART men is prayer.

739) Let it be known that prayer moves men and God into fragmented bits.

740) Let it be known that ceaseless cries offer the fragments a contaminate bite.

741) Let it be known there is no darker plague than bridging two fragments with LOGIC.

742) Let the two fragments—both godly and Smartly—rejoin instead with a Cat'i'th'gap!

743) Let cat particulars keep their odd time and vociferate at all hours.

744) Let cat thoughts keep a human body sweetly outside itself.

745) Let cattery soothe the kept man, be he a-bed, at-desk, or exiled.

746) Let the vox felis remind the weary: days at a desk ARE a kind of keeping.

747) Let the kept Man-at-desk worship the Cat like a leaping Byzantine.

748) Let the Man-at-desk go a-catting to squelch the roll and the prank of his mind.

749) Let a bout of Cat frippery parcel itself in waggles, for the Man-at-desk's delighting.

750) Let the Cat waggle visions pass desk to desk, man to man, as do the Ballads.

751) Let the Cat waggle tales enrich the desks of all held inward by drudgery.

752) Let Jeoffry's Cat waggle ditties goose the clock of the bedrugged.

753) Let the Cat waggles, in epic meditation, invade continent and colonies.

754) Let God bless the SMART family who sends a J waggle down the hump!

755) Let, after this, a waggle dream solve man's desky jeopardy, and to the letter.

756) Let J be the missing form—bless those who fly the keep at first watch!

757) Let E be the eye of Jeoffry, and the eye that, in watching, disremembers all I's.

728 *For every house is incomplete without him and a blessing is lacking in the spirit.*

729 *For the Lord commanded Moses concerning the cats at the departure of the Children of Israel from Egypt.*

730 *For every family had one cat at least in the bag.*

731 *For the English Cats are the best in Europe.*

732 *For he is the cleanest in the use of his fore-paws of any quadrupede.*

733 *For the dexterity of his defence is an instance of the love of God to him exceedingly.*

734 *For he is the quickest to his mark of any creature.*

735 *For he is tenacious of his point.*

736 *For he is a mixture of gravity and waggery.*

737 *For he knows that God is his Saviour.*

738 *For there is nothing sweeter than his peace when at rest.*

739 *For there is nothing brisker than his life when in motion.*

740 *For he is of the Lord's poor and so indeed is he called by benevolence perpetually— Poor Jeoffry! poor Jeoffry! the rat has bit thy throat.*

741 *For I bless the name of the Lord Jesus that Jeoffry is better.*

742 *For the divine spirit comes about his body to sustain it in complete cat.*

743 *For his tongue is exceeding pure so that it has in purity what it wants in music.*

744 *For he is docile and can learn certain things.*

745 *For he can set up with gravity, which is patience upon approbation.*

746 *For he can fetch and carry, which is patience in employment.*

747 *For he can jump over a stick, which is patience upon proof positive.*

748 *For he can spraggle upon waggle at the word of command.*

749 *For he can jump from an eminence into his master's bosom.*

750 *For he can catch the cork and toss it again.*

751 *For he is hated by the hypocrite and miser.*

752 *For the former is afraid of detection.*

753 *For the latter refuses the charge.*

754 *For he camels his back to bear the first notion of business.*

755 *For he is good to think on, if a man would express himself neatly.*

756 *For he made a great figure in Egypt for his signal services.*

757 *For he killed the Ichneumon-rat very pernicious by land.*

758) Let O be the illogic that circles itself with vigilance, like a Cat asleep.

759) Let F be Felidae Felis, which—O HOLY CATS!—is doubly fine.

760) Let R be not what we are, but what we err, and whate'er strikes us.

761) Let Y be YES; two short roads to a line, which is why, Jeoffry? And then yes, Jeoffry.

762) Let seventy-four lines of Cat-letting meet seventy-four lines of for-wanting-love.

763) Let a line of Cats waggling against the ceaseless prayer be love.

764) Let Jeoffry hover over the road and then let his low roving be love.

765) Let his feet pad the road and find a man, kneeling a-fours, for love.

766) Let his cat jig, cat bourrée, and cat sarabande be-spraggle the man as love.

767) Let a Cat to a drowning man be love.

768) Let love be his keep.

758 *For his ears are so acute that they sting again.*

759 *For from this proceeds the passing quickness of his attention.*

760 *For by stroking of him I have found out electricity.*

761 *For I perceived God's light about him both wax and fire.*

762 *For the Electrical fire is the spiritual substance, which God sends from heaven to sustain the bodies both of man and beast.*

763 *For God has blessed him in the variety of his movements.*

764 *For, tho' he cannot fly, he is an excellent clamberer.*

765 *For his motions upon the face of the earth are more than any other quadrupede.*

766 *For he can tread to all the measures upon the music.*

767 *For he can swim for life.*

768 *For he can creep.*

Sources Consulted

Neil Curry, *Christopher Smart* (Devon: Northcote House Publishers, 2005).

Clement Hawes, e-mail message with the author, May 13, 2014.

Chris Mounsey, *Christopher Smart: Clown of God* (Lewisburg: Bucknell University Press, 2001).

Christopher Smart, *The Poetical Works of Christopher Smart, I: Jubilate Agno*. ed. Karina Williamson.
 (Oxford: Clarendon, 1980).

WILL
BRADEN

CATS AND THE INTERNET:
A LOVE STORY

I MAKE CAT VIDEOS. MY BUSINESS CARDS have that printed on them (I do have actual contact information on the other side; I'm not a psycho). In 2006, I created the character Henri, le Chat Noir, an existential French feline philosopher struggling with ennui. In 2012, one of the videos in the Henri series won the Golden Kitty (the People's Choice Award and Best Picture Oscar combined, if you're a cat video auteur) at CatVidFest, the very first Internet Cat Video Festival. I've been involved in the festival ever since.

I made my first Henri video in film school. We had an assignment to make a "video profile," but I had procrastinated and was running out of time. I decided to make a humorous short film about a cat instead, hoping that if it were funny enough, my professor might not mind that I hadn't exactly followed the rules. We had been watching a lot of French New Wave art films, so the family cat, Henry, became Henri, le Chat Noir. The film was in French with English subtitles, the music was by Eric Satie, and it was, of course, in black and white. My plan worked—I got an A.

In 2006, YouTube was less than a year old, and Facebook videos and Twitter were still years away. So a video "going viral" wasn't even an idea. I initially put mine up on YouTube simply because a few people in my class wanted to show it to their cat-loving relatives. Years went by, and the video slowly developed a following. In 2012 (procrastination is a theme here), I finally got around to making a Facebook page for Henri, and within days it was flooded with people wanting to see more of the character. I decided to make a sequel, "Henri 2, Paw de Deux," and, with the benefit of share buttons and retweets, it took off like a kitten fleeing a vacuum cleaner. The first video had racked up three hundred thousand views in just under six years. The sequel got a million views in about five days.

Within a few months, it was clear that this was going to take over my life and become my livelihood, at least for a little while. Henri quickly got a book deal and a monetized YouTube account, and I created a website and an online store with merchandise like T-shirts and mouse pads. I felt guilty at first that I was commodifying something so simple and fun, but people really did want to support Henri—a T-shirt emblazoned with a logo is a modern shibboleth. And I was able to incorporate charitable contributions to everything associated with Henri. Soon, we were raising thousands of dollars for shelters and animal welfare organizations. I did well by doing good—if I gave 10 percent of the profits from a product to cats in need, I sold 15 percent more than if I hadn't. Cat people are generous by nature.

At the height of Henri's popularity (and with a third video just released), CatVidFest serendipitously began editing its first reel. Many people nominated Henri, and the second video ended up winning the Golden Kitty. A few days after I got back home from the festivities, someone pointed me to a tweet from Roger Ebert himself, declaring "Henri 2" the best internet cat video ever made. I had never purred so loudly in my life.

In every interview I've ever given about Henri or the festival, there has been a variation of the following question: "So what's with cats and the internet?" Sometimes the question will be delivered with feigned excitement. Sometimes it's asked with the muffled exasperation of a reporter who doesn't seem terribly enthused to have been given an assignment that's fluffier than a Persian's tail. Sometimes, though it's infrequent, people are so dubious they can't even be bothered to hide their incredulity. But to those of us who have always loved cats and cat videos, the real surprise is that their popularity *is* still a surprise to so many people.

We throw the term "cat video" around freely nowadays, but even as late as 2006, when Henri first made his appearance, it wasn't a commonplace thing. They had always been there—there was no shortage of cats on *America's Funniest Home Videos,* and of course there were famous cats in commercials, comic strips, and movies—but it was after YouTube exploded in popularity, and the ease with which we could share videos grew, that cat videos truly took off. The only thing was, no one was really talking about them. There's niche and then there's just plain embarrassing. Cat videos were dorky, and the people watching them were (we assumed) crazy cat ladies.

Only that wasn't even close to being true. Just as McDonald's is selling billions of burgers though no one will admit to going there, cat videos get millions of views from all over the world. That lady in your office always knitting sweaters for the cats in the pictures on her desk? Unless she watched that video of a kitten getting its tummy tickled on ten million different computers, she wasn't single-handedly keeping this phenomenon afloat.

Something began to change for cat videos in 2012. I think part of it was the rise of geek culture. Comic book movies were making millions of dollars, zombie shows were giving cable channels their highest ratings ever—niche markets were breaking into the mainstream, and a lot of things that were previously thought of as marginal were gaining real acceptance. It was becoming cool to like stuff that was uncool before. Cat video lovers could finally peek their heads through the cat door and proudly admit to their obsession. CatVidFest came right in the middle of this emergence and took it to a new level.

Which isn't to say that there wasn't blowback. Certainly a lot of ridicule was thrown our way by people reading about ten thousand viewers watching cat videos together. But the festivalgoers at the Walker that August night often found themselves changing sides. One of the best pieces about the event was written by Madeleine Davies for *Jezebel*. Even though she was a cat lover, her original plan was to show up and get lots of funny quotes from crazy cat people and, in her words, to mock as many of them as she could. But the crowd changed her tune. She expected a bunch of socially awkward cat people. What she found was the opposite. She wrote, "What *is* sad, I've realized, is that we've gotten to the point in which people gathering together and celebrating something positive is considered lame." It's impossible to stand next to ten thousand people sharing a joyful moment and be embarrassed by what you're experiencing. Cats may be solitary, but we humans find safety in numbers.

A few have made the argument that the internet has become a de facto cat park, since not many of those exist in the real world. Further, there is no Take Your Cat to Work Day. If you walk your cat on a leash, you will get strange looks. Cats are solitary, stay at home, and generally don't find any

merit to obedience or subservience. So solidarity with other cat people is part of the success of CatVidFest. But it's also worth noting that "cat video" is a nebulous term. I could show you three cat videos that have nothing to do with one another beyond featuring a cat. In a way, it's a bit like lumping every movie that's shot in Chicago together. Cat videos work as a genre because they can contain almost anything as long as there's a cat, and a wider net means more chance of catching great stuff.

There are also the sheer numbers to consider: Asking why there are so many cat videos is a bit like asking why so many photos of living rooms have couches in them. There are close to one hundred million cats in the United States alone. A third of households have at least one cat as a pet. Once you add the ubiquity of cameras, both with the takeover of digital technology and now with cell phones, it's not really a surprise that millions of people take millions of videos of their cats. It has been estimated that more than three hours of cat videos are uploaded to YouTube *every minute*. A cat getting his or her comeuppance is always good for a laugh, and cats are just *amazing* sometimes. As much as we see them daily, we're constantly surprised by their athletic ability, their mischievousness, their intelligence. Cats seemed predestined to be video stars. They just had to wait a few thousand years for those of us with opposable thumbs to invent the camera.

Cats, and videos of them, really do bring people joy. When you see a cat video and you decide to share it with other people, that's acting on an urge to spread that joy. Every time someone tells me they were having a lousy day and watching an Henri video made them laugh and forget about it for a few minutes, it is immensely gratifying. I try to keep that feeling in mind every time someone asks me what I do for a living and I feel momentarily sheepish before answering.

The other day, I mailed an Henri calendar to Zambia. The fact that millions of people in hundreds of countries can all be equally amused by the same ten seconds of a kitten falling asleep in its food bowl is a comforting thing to consider.

KEVIN NGUYEN

THE NO SLEEPING
CAT RULE

THERE WEREN'T MANY RULES, but the no sleeping cats rule was pretty self-explanatory: dozing cats were strictly off limits.

"Never any sleeping cats?" I asked.

"Never," my boss Emily said.

"Not even if they're *really* cute?"

"Never *ever*." Readers might confuse cats that were asleep with cats that were dead, and the last thing we wanted to do was upset our audience with a potentially dead cat.

It was my first day of work as a content manager at I Can Has Cheezburger, a website that published LOLcats—pictures of cats paired with captions in the sort of broken English that emulates the way a cat might talk.

Describing I Can Has Cheezburger to someone who isn't already familiar with it has always felt like explaining the punchline of a joke. You either get it or you don't, and every time I've attempted to pinpoint what makes LOLcats funny, I ramble on about the grotesque juxtaposition between the cuteness of the cat photo and the garbled language of the caption, or something similarly pretentious.

Here's the reality: Eric Nakagawa, a software developer from Hawaii, posted the original LOLcat, which bore the caption "I Can Has Cheezburger?" It first appeared in 2007 on the appropriately named backwater web community Something Awful, and Nakagawa, seeing its success, started a blog dedicated to the image macro. The site went viral and was soon breaking a million page views a month.

Later that year, a group of investors led by Ben Huh purchased the blog from Nakagawa for a rumored $2 million. It seemed improbable that

a single joke could sustain a stable, profitable business, but traffic ballooned from a million views per month to more than a million per day. By the time I joined the company in 2009, Cheezburger had grown into a network of sites and employed more than a dozen people.

We were headquartered in an innocuous office building in a quiet neighborhood in Seattle. Our floor was split by a partition; on the other side was the sales team of a medical supply company, with whom we shared a kitchen.

On my first day of work, I met a woman from the other side of the wall. She asked me what exactly we did at Cheezburger. I told her we were a website that published cat pictures.

Did we take the cat pictures?

We didn't; all content was user generated. People uploaded photos of their own pets.

She asked if I wrote the captions.

Not exactly, I explained. All submissions were voted on by the community. The images with the highest votes appeared on the site.

What exactly, then, did I do?

I didn't have a good answer for that. I explained that it was my first day.

The woman was polite and promised to upload a picture of her cat to Cheezburger if she could figure out how to get it off her phone.

If she had asked me what I did a month later, I'm not sure my answer would have changed much. I spent my days looking at the submitted images with the highest number of votes, which would surface through a customized page in WordPress. All I had to do was make sure there were no duplicates and schedule them to post the next day.

Unless Emily was out, I didn't even work on the biggest of Cheezburger's sites. The company maintained a network of sites that took the idea of an LOLcat to its logical conclusion across every other pop-culture topic. I handled the smaller ones, like ROFLrazzi (celebrities), Pundit Kitchen (politicians), Totally Looks Like (celebrity look-alikes), GraphJam (funny… graphs?)—a dozen in total.

I Can Has Cheezburger wasn't a publication; it was a business, hungry to attract eyeballs so it could sell digital advertising. And for a while, it worked. The company expanded quickly, hiring new contractors. There

was even a group called the "Farm Team," dedicated to launching new sites based on other internet-based jokes. With a staff of just twenty people, the company's annual revenue was in the low millions.

Cheezburger's motto, which our CEO, Ben, would repeat often, was "To make people laugh for five minutes a day." The press loved the modesty and humility of this, especially in an era when tech startups were claiming they could change the world via cheap Facebook imitations. Ben was also well liked by the tech media for being something of an outsider: he'd built his company in Seattle instead of San Francisco; in contrast to the excess of Silicon Valley, Ben prided himself on paying low wages, believing this created a culture where people worked because they wanted to, not because they needed the money.

At ten dollars an hour, my job paid about what I'd expected for a posting I'd found on Craigslist. It also reflected how little work I actually did. Picking images and formatting posts only took a few hours each day. I would finish up early, then spend the rest of the afternoon talking to friends on Gchat and reading funnier things on other websites. I'd just graduated from college into a post-crash job market, and I was thankful to have a steady gig at all.

Most of the employees, myself included, had been hired as contract workers. Our timesheets were limited to thirty-five hours a week so the company wouldn't have to grant us any benefits. If I had stayed for an entire year, I would've made less than $15,000 after taxes. Four months after I started, I was offered a job with a full-time salary that more than doubled what I was making. I told Emily that if she could match it, I would definitely stay. She couldn't, and later another employee told me that the reason was that they didn't want to set a precedent of giving raises to editorial workers. I don't know if that's true or not, but I parted with the company on good terms.

Not long after I left, *Gawker* published a piece called "Inside the Low-Paying Cheezburger Empire." The article was full of testimonials from other former employees protesting the company's policy on wages, hiring contractors, and unpaid overtime.

After the post went up, Ben sent an e-mail to his staff (later screenshotted and also posted to *Gawker*). "We really do want to make this a great place to work with no asterisks or fine print," he wrote. "I'd like to ask that

if you have any problems with the company that you help us solve the issue before talking externally."

It was a bad move, but not an uncommon one. But the reason the low pay was a story on *Gawker* had everything to do with Cheezburger's reputation. This was an emerging tech company—it was supposed to represent a new kind of workplace, one that was young and eccentric and cooler than the average job.

Maybe the difficulty in explaining I Can Has Cheezburger had less to do with the eccentric nature of LOLcats or internet humor and more to do with the fact that, as a company, it just wasn't that interesting. Sure, the product was offbeat, but the mechanics of the business were pedestrian. In the burgeoning age of internet humor, the scariest thing Cheezburger could be was boring. As a result, the company did everything it could to pretend it wasn't.

Ben had a network of websites that attracted millions upon millions of eyeballs, and he believed he could do more with it than sell ad revenue. When I was at Cheezburger, he talked about trying to sell a TV show, something that would leverage our archives into a half-hour program, a concept that, when described, sounded a lot like *America's Funniest Home Videos*.

Ben went to a lot of meetings, but I could never tell how far along he'd gotten. I wasn't involved, but it seemed like most networks weren't interested in programming that could be seen for free on the internet.

Then, two years later, Bravo announced it had greenlit *LOLwork*, a behind-the-scenes look at the people who worked at I Can Has Cheezburger. The opening scene features a discussion about the no sleeping cats rule— one that was almost identical to the one I'd had on my first day of work.

Emily is in the scene, as is Ben, who is pacing at a treadmill desk in the background. But aside from them, everyone I'd known and worked with at I Can Has Cheezburger had been replaced by people who were good-looking enough to be actors.

"Just as a general blanket rule, no sleeping cats ever?" asks Paul, the eccentric, bushy-haired content editor who had replaced me.

"People don't come here to see dead cats."

I'm sure the no sleeping cats rule has been told to just about every Cheezburger employee on his or her first day, but it's hard to separate myself from that moment. Reliving a conversation I'd had years before was like an out-of-body experience, only with poorer production values. The archetypes of my former colleagues were there, but this bunch was more attractive. Except Paul. The *only* ugly person on the show was the one mouthing dialogue on my behalf.

That scene is also the best in the entire show. And as I watched the rest of the episode, and the following five, I realized it was also the only one with any semblance of reality.

When I worked there, the Cheezburger office was sparsely furnished and lit by too-bright fluorescent lights. The layout was divided by several eye-level cubicle walls, that sectioned off the gray plastic folding tables where we sat. The office in *LOLwork* is in the same building, only dressed up with desks and chairs. Everyone is using new iMacs, and the toys and other distractions that decorate every corner of the work space reek of a desperate attempt to make the environment feel quirky and fun. Ben's treadmill desk stands in stark contrast to the server closet that acted as his office before.

LOLwork was short lived, never making it past its original six-episode run. Where LOLcats succeeded in making people laugh for five minutes a day, *LOLwork* found it much harder to make them laugh for twenty. Reviews were tepid at best. The *Boston Globe* described it as "inoffensive and dull."

The show had clearly been pitched as a reality TV version of *The Office*, with the added attraction that this was about an eccentric tech company instead of a paper company—a difference that's never quite acknowledged by *LOLwork*. Both the British and American versions of *The Office* succeeded as shows about work where the work is decidedly boring. Over the course of the show, the employees of Dunder Mifflin overcome the constraints of professional ennui to treat each other as more than colleagues. *The Office*, it turns out, is more preoccupied with friendship and love than it is with work.

LOLwork can't decide whether it's interested in work or not. There is a sense that the Cheezburger staff are all cat obsessives who perhaps take

themselves too seriously. Ali, a content moderator, proudly declares herself "fluent in cat lady." In the second episode, Ben says, "If we're going to do a feature on cats wearing hats, we better do it right."

At the same time, it's hard not to feel as if *LOLwork*'s characters are just a group of petulant adults who are largely lazy and don't really like each other: In the cold open of the fourth episode, Paul simultaneously plays a ukulele and a kazoo loudly at his desk. Almost all of the talking-head interviews are exposition or opportunities for a person to express his or her contempt for someone else. At its best, *LOLwork* feels acerbic; at its worst, the show is straight-up mean.

The imitation of *The Office* is lazy, but the show does dive into strangely ambitious metafictional plotlines. In the first episode, Ben has the Cheezburger staff team up to produce ideas for a webseries that will be "like a miniature TV show"—a show within a show right out of the gate. The fifth episode finds the office raising money so someone's cat can have $9,000 hip replacement surgery. The content team decides to run a telethon, complete with a talent show and bachelor auction. The episode becomes so high concept—another show within a show, as if it were Shakespeare—that it veers into pretension. *LOLwork* even has the audacity to feature someone performing Hamlet's "To be, or not to be" soliloquy translated into LOLspeak. All this teetering back and forth between clever and inane makes it impossible to know just how self-aware the show is, and what, exactly, it is trying to project, and to whom.

If there is a bright spot in *LOLwork*, it's watching the show do its best to establish romantic tension as quickly as it can in its six-episode run. The prospective pair also happen to be the most attractive people. There's Forest, a content editor who possesses the anxious charm of Adam Scott, and Sarah, the quiet art director who hides behind her bangs.

The show does little to disguise the manufactured nature of their courtship. In one episode, Emily prods Sarah about her feelings toward Forest, as if it's entirely normal and appropriate for your boss to ask you if you want to bang your coworker.

Still, this is where the cynicism of *LOLwork*'s cast is best employed. When asked about Forest and Sarah, some of the coworkers are nosey, while others remain apathetic. Will, the content supervisor, says, "Watching Forest try to pick up Sarah is like watching a dog hump a pillow. You just

want to look away." Later, he delivers the series' best line: "Listening to straight people talk about dating is very exhausting."

More than two years after the show ended, I e-mailed Forest to see if I could ask him a few questions about *LOLwork*. We never overlapped at Cheezburger, and he had since left the company and was happy to talk.

Forest explained that while the show wasn't scripted, it was "highly directed." No lines were given, but the producers planned out each scenario and situation. The same scenes were played out multiple times to catch them at different angles.

When I asked him what *LOLwork*'s semifictional depiction of the workplace was attempting to evoke, he urged me to not read too far into it. "It is much easier to sign a TV deal with producers and a network to spin a mostly fictional version of your company than it is to produce a show on your own that depicts how things really are in an office, good or bad."

He talked at length about the artifice of reality television—not necessarily a new idea, but one that was interesting to hear from someone who had been party to the charade. Forest believed that reality TV is made to give viewers what they want, and in this way, I couldn't help but think that this played exactly into Cheezburger's MO of putting what the readers want first.

The biggest surprise was that his relationship with Sarah was actually genuine. Or at least it became genuine. Forest and Sarah actually started dating toward the end of filming, and their relationship continued for another year before they broke up. Sarah confirmed this, also over e-mail. "Our relationship was genuine. A lot of it we actually had to hide from the cameras, rather than play it up."

It turns out the best part of *LOLwork* was also the most authentic. Despite what Forest said about it being easier to greenlight a show that plays to the conventions of reality TV, I couldn't help but wonder how much better the show could have been if the rest of its portrayal of Cheezburger had been as honest.

Two years after *LOLwork* aired, no one from the show was still at the company except Ben and Emily.

Though it grew quickly in its early years, I Can Has Cheezburger's growth flattened as its users moved from reading primarily on desktop computers to mobile devices. Ben raised an additional $30 million, raising the stakes of what Cheezburger had to become, to remain profitable. I heard stories from old colleagues that when the round of investment was announced, Ben went around the office handing out envelopes filled with $1,000 in cash to each employee.

In tech lingo, you might say the business "didn't scale." The company was spending much more than it was bringing in, and its decline is a familiar story about a business that had stagnated. Every expansion of the Cheezburger brand was more of the same, in different formats. For a site that was so beholden to its readers, it didn't understand them so much as it reacted to them. *LOLwork* was just another in a series of attempts to diversify I Can Has Cheezburger's business, along with books and other branded merchandise that Ben hoped would bolster the bottom line even as site traffic remained flat.

It didn't work. In April 2013, a third of the company was laid off. Since then, it sounds as if things at Cheezburger have stabilized. Ben writes somewhat regularly on Medium about what it's like to manage the company. He's reflective on his own shortcomings and the decisions that led to the company's failures. In one post, he concedes that venture capital transformed the company into "a confused, money-losing mess."

There has been a recent trend in treating business failures as a badge of honor, particular among startups. This, unsurprisingly, is how people talk about failure when they risk nothing, when you're in your early twenties and playing with someone else's money.

Ben is weighed down by his defeats. He talks about his mistakes in a way that doesn't intend to inspire pity, but to make amends with them. How often does a CEO talk about redemption?

I wonder what *LOLwork* would have been like if it had been on long enough to see the company diminished. What if the show possessed Ben's newfound self-awareness? This version of Cheezburger, the one in decline, is the one I wish I could see.

LOLwork paraded the no sleeping cat rule as an eccentric quirk of I Can Has Cheezburger, when in reality it serves as the most indicative example of the company's shortcomings. In that scene, employees are shot down for challenging a long-held belief that sleeping cats are inappropriate. It's played for laughs, unmindful of the fact that every joke eventually gets old.

SASHA
ARCHIBALD

FELINE DARLINGS &
THE ANTI-CUTE

IN REPLY TO ONLINE CAT VIDEOS, ARTIST Carolee Schneemann's *Infinity Kisses* (1981–1987) arrives like a missive from the past. The piece comprises a nine-by-seven-foot arc of Schneemann kissing her cats, 140 times, in close-up color photographs. These are not sterile pecks on the cheek, but full-throttle French kisses, the kind that distend the neck and leave glistening saliva all around.[1] The kisses are framed by pillows and bed-clothes, intimate objects on a night table, and Schneemann's mussed-up hair. *Infinity Kisses* landed with a silent thud in the art world, seemingly too eccentric and repulsive to warrant attention.[2] The piece proved an heir to the cautious repugnance relegated to cat women, those self-elected pariahs who have exchanged human company for feline and carry the molt to prove it.

Schneemann, the creator of the infamous *Meat Joy,* a 1964 performance involving animal carcasses, and the 1975 *Interior Scroll,* in which she read from a manuscript extracted from her vagina, has always had a knack for intuiting the point at which contemporary art's tolerance for transgression shudders and snaps. And yet on the surface, *Infinity Kisses* seems hardly so outré as these earlier works: no vaginal fluid and no raw meat, only methodical documentation of a cat's belovedness. In fact, like Schneemann, we love our cats, kiss our cats, and film our cats. Cats play an outsize role in our emotional lives. The puzzle of *Infinity Kisses* is not that it is a paean to cat devotion to which we can't relate, but a paean to cat devotion that thoroughly evades the aesthetic of "cute." Cute is the affect cat photography tends to produce nowadays, and it is certainly the lingua franca of the online cat video. Schneemann's piece results rather in a squeamish gulp. Like a musty tropical fruit or a beloved cat in heat, *Infinity Kisses* tips the line between delectable and revulsive.

A handful of writers and critics have recently turned their attention to the cute, plumbing it with the sort of gravitas usually reserved for the beautiful or the just. The provocative sum of these analyses is that the characteristics of cute belie its true essence. Appearances to the contrary, cute is neither petite, sweet, nor vulnerable, but bombastic, evangelical, and sadistic. William Burroughs wrote about control as having an inherent quality of boundless propagation, such that exercising control has the paradoxical effect of begetting more control. Cuteness shares this tendency toward explosive proliferation. As a visual experience, it has the characteristics of addiction; looking at cute things breeds the desire to look at more cute things, such that icons of cute are pasted on points of constant contact: calendars and screensavers, refrigerator magnets and bulletin boards. Moreover, the apex of cuteness is a flexible point, spiraling out further and further. Eyes grow bigger, features rounder, texture more uniform, colors more soft. There is always one critter cuter than another, such that cuteness implies an interminable search and a contest for the ultimate cute, albeit a contest of biased judges who unabashedly proselytize.[3] The highest level of praise in the cute lexicon—"Isn't it cute?"—is a judgment disguised as a question, to which there is only one acceptable answer. Devotees of cute coerce agreement, thrusting their cell phone before your eyes, chirping in a sunny way that silences dissent.

Eventually, cute's ravenous appetite eclipses functionality. The child is so gussied up she can't eat or play, and the kittens are wearing bonnets and socks. In Japanese, "kitten writing" describes handwriting so extremely rounded it's no longer legible.[4] Cuteness does not pause and rest content.

The finale of this crescendo effect is the transition from cute as a mode of apprehension to a mode of tactility, from looking to touching. Cute theorist Sianne Ngai argues that touchability is a core property of cuteness, one of its definitive characteristics. Whether animate or inanimate, cute things emit a recognizable siren call, signaling (in their cute way, with a squeak or a whisper) that they want nothing more than a good fondling.[5] The commonplace expression of cute, the plush toy, is designed for such bodily manipulations, built for squishing, pressing, squeezing, dragging, and stroking. For a time, my daughter insisted on carrying her stuffed monkey layered beneath her clothes, tucked inside her underwear, a gesture that expressed her great affection even as it suffocated and cannibalized her animal friend. This sort of loving molestation—the very response cute seems to demand—is rooted, argues Daniel Harris, in the sadistic. Cute dolls and animals and toys are specifically deprived of the appendages that would let them fend off touch. In the course of the twentieth century, the arms of stuffed teddy bears grew shorter and shorter, cuter and cuter with each amputation. "Although the gaze we turn on the cute thing seems maternal and solicitous," writes Harris, it "will stop at nothing to appease its hunger for expressing pity and big-heartedness, even at the cost of mutilating the object of its affections."[6] Poet Frances Richard makes a similar point, employing a kitten to demonstrate (and confess) that the stirrings of the sadistic often follow on the heels of the cute. "It is horrifying," she writes, "to feel the fragile bones and heartbeat warmth of the actual kitten in one's hands, and to feel those hands flexing, as if of their own atavistic accord, to crush."[7] Cuteness and cruelty are bedfellows more often than we care to admit.

By positing a cat with agency enough to consensually kiss, Schneemann's photographs refute cuteness, whereas the ordinary online cat video stokes its fire. The cutest videos are those that depict a cat in a predicament, just as the most beautiful women are those, according to Edmund Burke, who "counterfeit weakness, and even sickness."[8] The index of cuteness is the degree to which an object sheds its power. Nothing possessed of full

sentience can be cute, at least not simultaneous to it achieving cuteness. The aesthetic brokers no autonomy; an objectified subject is prerequisite. No wonder cute's operational mode is so often photography and video.

How, then, did cats become the cute icon extraordinaire? Unlike Hello Kitty or Beanie Babies or Pillow Pets, not only are cats alive— already an impediment to cuteness—but they scratch and bite, use urine as a form of protest, and, perhaps worst of all, kill other cute things. They command attention and accommodation, shamelessly exerting control over an entire household. Cats are notoriously conceited, supremely confident of their dominance. When a cat deigns to offer comfort and companionship, the relationship remains of the cat's design, contingent on its capricious inclinations. As most cat lovers acknowledge, the cat's imperviousness is key to its charm. Knowing the object of our attentions will never be subjugated makes its pursuit enjoyable: In chasing the cat's exquisite not-need, we allow ourselves to need. The tension between human agendas and kitty self-determination lies at the very heart of feline devotion. In a cat-and-mouse-game of our own invention, we attempt subjugation, and the cat resists, over and over and over. With the online cat video, however, our attempts at mastery have acquired their most powerful arsenal to date. Camera in hand, the cat is forced to yield its dignity, abandon its claims to privacy, and finally acquire a reputation wholly counter to its ancestral roots. The ancient cats of myth, literature, art, and even early twentieth-century popular culture bear little semblance to today's big-eyed kittens. YouTube speaks a tale of catness thoroughly at odds with feline history.

The shift is recent. Even just two hundred years ago, cats were operative symbols of qualities antithetic to cute: magical metamorphosis, potent danger, sexual provocation, and impervious autonomy. Take for instance, the feline's long-standing association with feminine sexuality. Whereas cute suggests a virginal and yet available sexuality—the aesthetic is a placeholder for the eroticization of succumbing to another's desire—cats were historically the indicator of women's self-determined sexual prerogative. The links between pussy the cat and pussy the cunt extend over centuries of folklore, a connective tissue that binds the contemporary Russian punk-protest group Pussy Riot with ancient Egyptian celebrations that honored the cat goddess Bastet. In

Herodotus's account of these festivals, thousands of women crowded onto barges and traveled down the Nile, wildly dancing and drinking wine (more wine, Herodotus noted, than at any other annual holiday). As the barge passed by men on shore, the women flipped up their skirts to reveal nothing underneath. To celebrate the cat was to tout the pussy.

The fairy tale cat is almost always a syllogism for pussy as a provocation. In a Romanian fairy tale, for instance, when a young woman refuses to yield to her lovesick suitor, he is so brokenhearted he commits suicide, and she is punished for his death by being turned into a cat.[9] Her feline form becomes a warning to other young women of the dangers of nonconformity; by threat of cat transformation, women yield their bodies. Just as a woman who refuses sex becomes a cat, so does a woman too eager for sex, or a woman who seems to love cats more than sex. Or a spell might command that a young woman become a cat the day of her eighteenth birthday, the symbolic moment at which she could exercise her sexual autonomy. In the reverse, a man who demonstrates kindness to a cat might be surprised with a beautiful lover—a lover who may or may not retain the head of a cat.[10] So permeable was the boundary between feminine wiles and kitty cats that in the Salem witch trials, a woman wasn't considered completely dead until her pet was also murdered.

It is no surprise then that the consummate scene of feminine come hither-ness in art history—Édouard Manet's *Olympia*—includes an enigmatic cat. Manet's nude is in placid repose, her body there for the taking but her sentient feeling concealed. Just as Olympia's diffident gaze ignores the servant handing her flowers, so does she rebuff the viewer's attention. Bored and aloof, her tidy hair and rouged cheeks suggestive of perfunctory, rather than amorous, coitus, Olympia's internal self is pointedly hidden. In Manet's time, Olympia's ambivalence was less decodable, and his contemporaries instead seized on the cat at the foot of the bed. It was the pet cat, they decided, that made plain the subterranean gist of Manet's intention. The animal that punctuates the scene in Manet's model for the painting, Titian's *The Venus of Urbino*, is a fluffy white lapdog nestled in the sheets—a symbol, art historians report, of marital fidelity. Manet's animal accent is Titian's opposite: a black cat. Hair on end, tail stiff, back arched, with electric yellow eyes, the cat appears agitated or even aroused, the sort of matted-fur, caterwauling animal more at home in an alley than a lady's bed. The cat was exaggerated in cartoons that mocked the painting, depicted as much larger and more central to the composition, the spike of the fur exaggerated and the tail shooting straight up. *Chat noir* had since the Renaissance been a euphemism for women's genitalia, such that Manet's audience directly linked the private parts clamped beneath Olympia's palm with the arching black cat by her dirty ankles. Given the symbolic import of *chat noir*, the painting was indeed as pornographic as its detractors claimed. Manet's friend Émile Zola, one of the painter's few defenders and himself no stranger to calculated provocation, marveled at the audacity of it: "[T]o have put such a cat into that painting, why, [Manet] must have been insane. Imagine that! A cat—and a *black* cat at that!"[11]

As Zola perceived, it was the cat in combination with the nude—a nude depicted as a naked woman rather than an idealized female form—that signaled the degree to which Manet was flouting convention. And flouting convention, in turn, became the enduring reputation of the cat. Although "pussy" is still crude slang for a woman's sex, cats in the late nineteenth and early twentieth centuries were more likely to be used as symbols of nonconformity—when the powerful labor union Industrial Workers of the World needed an emblem of strike, they chose a cat. This symbology helps explain the cat's enduring alliance with artists and writers,

and why certain gatekeepers of high culture have no qualms contributing to the schmaltzy genre of cat books and cat art. Many times over, cat-loving literati, particularly Francophile cat-loving literati, have been tallied, photographed, and quoted; their ranks include the most accomplished of thinkers. The cat is the preferred pet of the cultural elite, naturally gifted with qualities creatives like to claim for themselves: insouciance to public opinion, for instance, and unshakable self-assurance. In the famous title essay of *Under the Sign of Saturn*, Susan Sontag describes writer and critic Walter Benjamin with terms that might have been just as well applied to Benjamin's (imaginary) cat: "secretiveness," "feelings of superiority," a tendency toward "scrupulous manipulation," and "faithlessness."[12] Sontag herself so successfully emulated the cat that she was pictured in memoriam as "a big lady she-cat [basking] in the sun."[13]

The qualities intellectuals celebrate in the cat are the same ones others denigrate. Whereas the nineteenth-century American relationship between slave and master, for instance, had been commonly understood as that between a man and his dog—a dog had to be trained, disciplined, and controlled and would render useful service in return—blacks who exercised new freedoms upset this imagery; as a result, they were suddenly characterized as cats: ungovernable, disobedient, uncomprehending of order and decorum. The feline comparison was extensively used to discredit progressive social thought that advocated racial equality. In Thomas Dixon's 1902 novel *The Leopard's Spots*, a white reformer is mocked when her interlocutor, a Southern preacher, points out that she endowed a home for homeless cats before she took up the Negro cause, the implication being that both projects are equally stupid. "Training black men," writes Jennifer Mason, was perceived to be "as futile and idiotic as training cats."[14] Cats and blacks were almost interchangeable in the writings of scientist Nathaniel Southgate Shaler, the author of several influential books on racial difference, who also published on the animal kingdom. Shaler hated cats—"the only animal which has been tolerated, esteemed, and at times worshipped without having a single distinctly valuable quality"—for the same reason he hated blacks. Both exhibited, he said, a lack of loyalty, an "inability to be trained," and a stubborn resistance to domestication.[15]

Whether an honorable or dishonorable rebel, the cat was ready at hand when cartoonists began experimenting with animation cells. It was

a perfect marriage: a genre that could graphically depict changeability and a notion of cats as freewheeling, capricious rogues. Felix the Cat debuted in 1919 with a combination of genre, style, and species that was pitch perfect. "It seems as though the cat's personality," writes animation historian Donald Crafton, "was understood and appreciated almost overnight."[16] For nearly a decade, Felix cartoons were screened near constantly in cinemas around the world, inspiring merchandise spinoffs, sports mascots, military insignia, mixed drinks, pop songs, bars, and restaurants. (It was Felix who evidenced the creative potential and audience appeal of animation, paving the way for Disney's menagerie, which began, incidentally, with a short-lived character named Julius—a cat who looked so similar to Felix that Disney scuttled the character after a lawsuit and staked its fortunes instead on the cat's rodent nemesis.) In these early cartoons, Felix is unfettered by home or family, geography or time. Conveyed by a wisp of smoke or a surge of volcanic magma, Felix travels the world and beyond, visiting outer space, the depths of the sea, fairy tale land, and back in time. Even his bodily integrity is provisional; he melts, dissolves, and coagulates, detaching his tail to use it as a knife or a toothbrush or a scooter and becoming something other than a cat whenever escape is paramount: a lady's hat, a can of salmon, a dirigible, a block of ice.

FELINE DARLINGS & THE ANTI-CUTE

Despite the comedy of his predicaments, Felix cartoons often hint at their firsthand war experience of animator and audience, particularly in Felix's many journeys beyond the pale. Felix's capacity for reincarnation—a holdover of the fairy tale cat of seven lives—must have softened the misanthropy of a character who finds so many ingenious ways to commit suicide. Compare Felix's suicide mission to that strange figment of twentieth-century catness: Tigger, of A. A. Milne's *Winnie-the-Pooh*. Striped like a tiger but with a character clearly modeled on a kitten, Tigger is best known for his spastic enthusiasm and paean to durability (written by Disney, not Milne): "Tiggers are wonderful things! Their tops are made out of rubber, their bottoms are made out of springs!" He chants this rhyme on repeat, punctuating it with a hysterical giggle. Whereas Felix feels the burden of living, Tigger, with a coiled spring attached to his rear, would no more wish to die than a pogo stick.

Many animated cats followed, but Felix was the swan song of a metonymical relationship between a fictive, personified cat and an age-old understanding of catness. Cats were on the cusp of a momentous transition toward greater passivity—if not in their actual disposition, then in relation to their human companions. In the next few decades, a series of scientific innovations (vaccines, insecticides, reproductive surgery), in tandem with the birth of the pet industry (cat food, kitty litter, pet accouterments), brought about great changes in pet-keeping.[17] The shift was quietly presaged by Charlotte Gilman's *Herland*, a 1915 account of a futurist utopia. Among the peculiarities of Herland, Gilman explains that the inhabitants have only cats as pets (no dogs), specifically only cats that do not cry. In Gilman's fantasy, Herland's felines have been bred as perfect pets: they purr but never meow or howl, register pleasure but never request it. In 1915, the notion of a made-to-please cat was as radical an idea as female separatism, and yet far closer to becoming reality.

First, a vaccine for the common and fatal disease of feline distemper dramatically extended cats' life spans and presumably made cat owners more inclined to attach to their pets. Feline-human intimacy also became more profuse with an insecticide for fleas. Without threat of fleabites, cats were welcome to sleep in the family bed and sun themselves on the couch. Veterinarians turned their practices from livestock to pets and began to offer spaying and neutering, relieving cat owners of the annoyances of an

animal in heat and the nasty task of murdering kittens. Cat food appeared on supermarket shelves in the prosperous years after WWII. At about the same time, kitty litter was first marketed. In the space of just a few decades, cats that had taken regular sojourns outside—to mate, hunt, and use the bathroom—now took none at all, their cosseted lives beginning and ending inside the front door.

In tandem with newfangled inventions like dry pet food, public health initiatives in family planning resulted in smaller families. Choosing to abstain from the demand of a child did not, however, ameliorate the need to have something to love, and cats—small, tidy, low maintenance—proved the perfect candidate. The emotional rapport between cat and keeper was further deepened by the animal welfare movement. Clubs for children that promoted animal kindness (Bands of Mercy), and a surge of popular literature written in the animal first person endowed pets with sentient selves, albeit of human design. The conceit of dressing animals in human costume was astoundingly successful in curtailing animal abuse—Anna Sewell's *Black Beauty* ranks among the best-selling books of all time—but there were other, less happy consequences. By invoking Christian notions of charity and mercy, the animal welfare movement necessarily positioned felines as defenseless and vulnerable. On the upside, cats were no longer drowned; on the downside, they were perceived as creatures that had been rescued from drowning. Cats play this role awkwardly; feline grandeur does not mesh well with the humility expected of a supplicant. Yet absorbing such tension is precisely where cuteness shines: "the conventions of cuteness," writes Harris, "are the residue of unfulfilled wishes."[18] In sum, the pet cat was bridled by human heartstrings and tugged further from the wild and closer to the hearth, until finally—contained in the home, cosseted from discomfort, served a special menu, stripped of sexual prerogative, and subject to the same degree of devotion as a child—the cat was primed for viral stardom.

The original online cat video is not a video, but a little-known art film, produced the same year kitty litter hit the supermarket: Alexander Hammid (née Hackenschmied) and Maya Deren's *The Private Life of a Cat*.[19] In their twenty-five-minute silent short, Hammid and Deren film their cat, Glamour Girl (or Gigi for short), giving birth and tending to five kittens. Gigi's cardboard box labor is as lowly and sublime as a biblical birth

in a manger. She cozies up as her kittens spool out from folds of pink flesh, ectoplasmic bundles of slime. She licks them into life and their fur spikes up; they flop about, nosing for a teat. When a placard indicates two weeks have passed, Gigi carries each by the scruff of its neck to an unused fireplace, where the kittens learn to walk and climb and lap cream from a saucer. Deren is deservedly celebrated as the grande dame of avant-garde film, and even this whimsical piece is stately and honorific. The shots are beautifully framed—shafts of light in a Hollywood bungalow—and the editing is witty and charming. Yet, like its less-polished cousin films, *The Private Life of a Cat* projects a version of catness that has little to do with cats. In peeking in on the cat's interior self, Hammid and Deren find no trace of alterity, but rather the familiar saga of an idealized mother. For all its delight, *The Private Life of a Cat* trespasses the privacy of a cat to satisfy the vanities of a human. Coddled and cuddled and photographed ad nauseam, cats like Gigi will soon be pressed in the mold of *America's Funniest Home Videos*. Pray we don't return to a time when children are indulged in setting cats on fire. And yet, are the sticky moans of cuteness endemic to cat love? Are there other ways to treasure an animal?

It's a dangling question, unresolved even in regards to human babies, let alone cats. There is, however, one apropos suggestion by the late philosopher Jacques Derrida. The cat could be restored its dignity, he suggests, by occasionally reversing the spectral terms of the human-feline relationship. In a late lecture, Derrida analyzes the primal scene of his adulthood: he is undressed, preparing to get in the shower, and his cat

appears. The animal stares at Derrida's naked body, gazing like a sphinx, or "an extra-lucid blind person."[20] The cat's gaze induces a cataclysm of discomfit. Derrida feels mortification and shame, he writes, but also a sense of momentousness. The encounter stages a threshold. He and the cat are frozen in space and time, eyes locked in a quiver of interspecies communication. "Something happens there," writes Derrida, "that shouldn't take place."[21] (Indeed, a similar scene, described in Edgar Allen Poe's 1843 story *The Black Cat*, is the stuff of horror. The narrator becomes so unnerved by his cat's gaze he savagely puts out its eye.)[22]

It is only when this moment dissolves, Derrida reflects, that he can visit animals in a zoo, or enjoy paintings of animals, or stroll through dioramas at the natural history museum, or read about animals in a book, or, presumably, gorge on online cat videos. Gazing into the cat's eyes holds in abeyance these other forms of looking, such that the cat is allowed, briefly, to be something other than a toy or a surrogate or entertainment, something more majestic, peculiar, and potent . . . something more cat. Henceforth, a new requirement: Before producing or consuming a depiction of catness, one must first submit to the gaze of the cat. Assume the posture of "a child ready for the apocalypse": naked, no camera allowed, ego tucked between the legs.[23] Don't be surprised that should the apocalypse arrive, the cat will take its vengeance on cute. Brace yourself for an interspecies French kiss.

Notes

1. *Infinity Kisses I* (1981–1987) was followed by a second photo grid, *Infinity Kisses II* (1990–1998), and by a video, *Infinity Kisses—The Movie* (2008), which incorporates images from the two photo works and is available online: https://www.youtube.com/watch?v=_m4wuJH4M8I.

2. *Infinity Kisses* builds on explorations Schneemann took up twenty years earlier with *Fuses* (1965–1968), the premise of which, as Schneemann describes, was to visualize her sex life through the eyes of her cat, Kitch. Schneemann filmed herself with her partner at the time, composer James Tenney, and then assiduously marked the 16mm footage with heat, water, paint, and ink. The final product is a sex film that lacks the hallmarks of a sex film—no fetishized nude and no drive toward climax—and instead captures the texture of lovemaking, rendered as a series of flickering affects. Human sex from a cat's perspective seems innocuous enough as a description, but for two decades, *Fuses* outraged audiences. At a screening in Cannes, theatergoers ripped

apart the seat cushions in disgust. At another in El Paso, Texas, the projectionist was assaulted and arrested. As recently as 1988, the film was cancelled from the program of a film festival in Moscow.

3. Artist Nina Katchadourian's *Continuum of Cute* literalizes this contest by arranging one hundred animals in a linear trajectory (least cute to most cute) and inviting viewers to do the same: http://archive.rhizome.org/exhibition/montage/katchadourian.

4. Frances Richard, "Fifteen Theses on the Cute," *Cabinet*, Summer 2001, 96.

5. Sianne Ngai, introduction to *Our Aesthetic Categories: Zany, Cute, Interesting* (Cambridge: Harvard University Press, 2012), 1–52.

6. Daniel Harris, *Cute, Quaint, Hungry and Romantic: The Aesthetics of Consumerism* (New York: Basic Books, 2000), 6.

7. Richard, "Fifteen Theses on Cute," 95.

8. Edmund Burke, "On the Sublime and Beautiful," in *Harvard Classics*, vol. 24, ed. Charles W. Eliot, LL.D (New York: P.F. Collier & Son Company, 1909), 29–137.

9. This fairy tale is the subject of a book-length Jungian analysis by Marie-Louise Von Franz, *The Cat: A Tale of Feminine Redemption* (Toronto: Inner City Books, 1999).

10. Sylvia Townsend Warner cleverly scrambles these fairy-tale motifs in her novel *The Cat's Cradle Book*, in which a woman stumbles upon a remote cottage inundated with cats and inhabited by an enigmatic man. To atone for a past sin—he was so irritated by his cat in heat, he dumped water on her head and she subsequently died—the man has taught himself cat language in order to study cat folktales. He makes love to his visitor (with a decidedly feline technique), and asks her to share the burden of his task.

11. John F. Moffitt, "Provocative Felinity in Manet's *Olympia*," *Notes in the History of Art* vol. 14, no. 1 (Fall 1994): 21–31.

12. Susan Sontag, *Under the Sign of Saturn* (New York: Macmillan, 2013), 18–19.

13. Terry Castle, "Desperately Seeking Susan," *London Review of Books* vol. 27, no. 6 (March 17, 2005): 17–20.

14. Jennifer Mason, *Civilized Creatures: Urban Animals, Sentimental Culture, and American Literature, 1850–1900* (Baltimore: Johns Hopkins University Press, 2005), 142.

15. Ibid., 141. The creators of Felix the Cat exploited racist stereotypes to increase the comedic appeal of the character. Felix was the brainchild of Pat Sullivan, whose first venture into the business was an animated version of Little Black Sambo, from the eponymous 1899 children's book by Helen Bannerman. Sullivan depicted Sambo with inky black skin, thick lips, buckteeth, and a swollen belly. Sullivan's commercial success with Sambo was interrupted by a jail sentence—he was convicted of raping a fourteen-year-old—and upon his release, he set the character aside and launched Felix the Cat. His depiction of Felix, however, also relied on various stereotypes of African American culture, albeit of the exotic type. The cartoons established Felix's edgy sensibility by drawing on hallmarks of 1920s Harlem. Felix's nickname, for instance, is Jazz Baby, and in a print advertisement for the cartoon, Felix learns the "Black Bottom," a dance from the rural South that made its way to Hollywood via Harlem. See Patricia Vettel Tom, "Felix the Cat as Modern Trickster," *American Art* vol. 10, no. 1 (Spring 1996): 64–87; and John Canemaker, *Felix: The Twisted Tale of the World's Most Famous Cat* (New York: Pantheon, 1991).

16. Donald C. Crafton, *Before Mickey: The Animated Film 1898–1928* (Chicago: University of Chicago Press, 1993), 307.

17. Katherine C. Grier, *Pets in America* (Orlando, FL: Harcourt Books, 2006).

18. Harris, *Cute, Quaint, Hungry and Romantic,* 15.

19. Hammid is credited as the director, but later said the film was Deren's idea and that they worked together. Deren is the sole author of an introduction to the film included with the DVD *Maya Deren: Experimental Films* (Mystic Fire Video, 2002).

20. Jacques Derrida, "The Animal That Therefore I Am (More to Follow)," trans. David Wills, *Critical Inquiry* vol. 28, no. 2 (Winter 2002): 369–418. In the scene Derrida describes, he is frontally naked, and the cat, he emphasizes, is not an abstraction or an archetype but a singular cat with a singular personality: his cat. Peter Trachtenberg writes about the exact same moment in his memoir, *Another Insane Devotion: On the Love of Cats and Persons* (Boston: Da Capo Press, 2012), describing it as one of exquisite vulnerability. Stroking the cat while naked combines two postures—defensive protectiveness and demonstrative affection—that are otherwise inimical.

21. Derrida, "The Animal That Therefore I Am (More to Follow)," 369–418.

22. In several respects, Poe's story draws on real customs of seventeenth-century France, detailed in Richard Darnton's *The Great Cat Massacre* (New York: Basic Books, 1984). For instance, it was believed that the trick to disabling a cat's powers of sorcery was to maim it: "Cut its tail, clip its ears, smash one of its legs, tear or burn its fur, and you would break its malevolent power" (92, 94). In the same period, live cats were bricked into the mortar of new homes, a custom believed to protect the hearth. Poe's feline character suffers an identical fate, except it remains alive, meowing from inside a wall to betray his master.

23. Derrida, "The Animal That Therefore I Am (More to Follow)," 369–418.

Photo Credits

Page 107: Carolee Schneemann, *Infinity Kisses II (Vesper)* 1990-98, laser prints, 24 self-shot laser prints 26 x 20 inches, each 113 x 136 inches, overall. Courtesy of C. Schneemann and P.P.O.W Gallery, New York.

Page 111: *Vintage Pussy Flip Up Peep Book.* Circa 1894. From the collection of the author.

Page 114 (left): "Felix Learns the Black Bottom," from *Photoplay* (January–June 1927). Digitized by the Internet Archive in 2009 with funding from Media History Digital Library, http://mediahistoryproject.org/fanmagazines.

Page 114 (right): Unknown Photographer, *Felix the Cat toy – Nielsen Park Beach, Sydney,* NSW, 1926, Mitchell Library: State Library of New South Wales, At Work and Play – 01163.

Page 118: Aubrey Beardsley, *The Black Cat,* 1901, print, Library of Congress General Collections (NC1115.B43).

JOANNE MCNEIL

FINDING HALF CAT

WHAT IS WHITE AS SNOW, FLUFFY, BIPEDAL, has a slightly menacing look, possesses an errant tail, and stands about ten inches tall? Half Cat!

Half Cat is captured midstrut, proud and surly as a feline boxer. He appears hunched over, his tail jutting out like a truncheon. He has no ears. His furry head melts into his neck with the posture of a bald eagle. This cat means business.

I found out about this mysterious creature after a Twitter account called @streetviewfunny tweeted his image in May 2013.[1] With nothing more than an image and a quick description ("Google Street View cuts a cat in half"), I quickly started plugging in dozens of Google search strings in an attempt to track down the coordinates for this image error.

"cat glitch street view"
"half cat white cat geocoordinates"
"street view glitch cat location"
"cat map cut in half"
"two-legged cat google map"
"google street mutant cat"

I had to see him! I wanted to see the cat in the context of his digital environment. It wasn't enough to marvel at someone else's screenshot of him. Perhaps the Google Street View navigation controls would elongate the error, and I could take an even weirder image than the one provided here. Or maybe the image was taken in a place that was familiar to me, near a school I attended or another landmark somewhere in a city I love.

It is hard to explain the desire to see something in its online habitat. Browser tabs are the collages we build to live in and see through. Google Street View is a portal into another world, a frozen mirror of our physical landscapes. I sometimes get lost in the web app for hours. Researching a location, I might twist and turn down streets, astonished by its failed translation of space—the glitch renderings, banding, Bayer artifacts, color distortions, and chromatic aberrations that remind me that I'm exploring a virtual world. It is the world as a multieyed, panoramic camera sees it. I wanted to see Half Cat where he lives on the internet for the same reason I would go to see a famous work of public art while visiting a new city.

There are many blogs and websites devoted to Google Street View exploration—"virtual tourism," maps to the strangest glitches and odd sightings inside—but none of them had any clues or information on Half Cat. Reviewing new replies to the original tweet, I realized I wasn't the only one hunting down his location. I turned my attention to another project, assuming that Half Cat's location would be crowdsourced in time. There was even a *Gawker* post requesting its coordinates ("Where on Google Street View Can I Find This Wonderful Half Cat?").[2] One of the first people to comment slyly posted an image of a red Google Map flag marking Cheshire, Connecticut. Another commenter suggested the half cat could be found on Diagon Alley, Harry Potter's fictional, wizardy road. (Coincidentally, Google Street View unveiled its clone of the Harry Potter film set in England just a few months later.)

Nothing in the background of the image of Half Cat was distinctive enough for anyone to identify it as a familiar landscape. There are no landmarks in the picture or unique environmental elements. If there was, say, a palm tree in this image, that could at least narrow the search down to hot climates. But there's just pavement on the ground and gray bricks behind him. Half Cat could be anyplace. It seemed the fastest way to find the cat would be if the person who took the screenshot came forward. The only

alternative was for someone else who had seen the cat inside Street View to come forward, because presumably, it's just another white cat on the street. Only through the nine-eyed camera does he reveal himself as something uncanny. If neither happened, the cat could be lost a long while. That's the thing about Google Street View: it has Xeroxed so much territory, there are images in there that no human eyes have seen. Another thought occurred to me: Perhaps Half Cat was photographed in a city that Google Street View has since refreshed with updated images. It's not yet possible to look at previous images. We were hunting down this cat in both time and space!

At the end of the day, another image was added in the comments to the *Gawker* post. It was a full-sized, properly eared, four-legged white cat in front of a stone fence matching the shape and color of the one in the background of the original image. "This is an obvious photoshop reconstructed from the original half-cat," said a *Gawker* editor replying to the comment. It's unclear whether he was joking or not. I spent another twenty minutes reviewing both images, searching Twitter, and trying to find out whether this was just another hoax. A reverse image search of the picture of the white cat revealed that yes, this was the original photograph. Half Cat wasn't a Street View glitch at all. It was a joke Photoshop job.

Most of us have settled debates with our phones. For example, if your dinner party guests wonder which country has the largest total area after Russia, Canada, China, and the United States (Antarctica, parenthetically), you could pull up a relevant Wikipedia page in seconds, before the two insisting on Brazil or India pick up their knives to joust. But we need to

be careful of relying on the internet for all the answers—hoaxes, rumors, and half-truths abound.

Recently I came across a post in a forum asking the question, "What is the Dario Argento movie that has nested realities within realities?"[3]

> I remember a guy looking at a TV screen and the character thinking "Which level am I at?" I think it had to do with TV specifically, and the "pops" between levels would always happen with TV screens.

> Artistically it was breaking down the notion if you the viewer were in the movie or not. Great stuff. A precursor to the movie *Inception.*

> I don't know if this was Argento, but I think for sure 80s Italian horror, and if not Argento, who?

In the comments, people suggested *Brainstorm, Dreamscape, Strange Days, They Live, eXistenZ, Tron,* and *Videodrome.* But no one had the answer. It's possible the original poster misremembered the film. Or maybe it was just too obscure. Some memories are still locked in mental black boxes, unable to ever be confirmed. Sometimes the answers aren't there.

WikiLeaks once tweeted a link to a 2010 BBC story, "Swedish rape warrant for WikiLeaks' Assange cancelled," two years after the story appeared and despite recent updates that the warrant was upheld. For a brief time, the story was among the BBC's most viewed articles that day. While a number of people caught this—perhaps intentional—error, undoubtedly a few readers did not.[4] The website looks no different than it did when the story first ran. There are no visual signifiers of the story's age. Things like Half Cat happen all the time online, just to varying degrees of chaos and confusion. Everything is slippery and mutable. The internet is its own wilderness, blending the boundaries and redefining our understanding of what is fake or real.

That could be why Street View is so uncomfortably familiar. It's often unclear whether images were photographed yesterday or years ago. With some areas of Brooklyn, particularly by the East River, you might stumble upon an accidental before-and-after of the area's gentrification. Photographs from the past year are stitched together with images from

several years previous. Press down on an arrow to pass the bright water-front condos and enter the decaying industrial area that was there not long before. Street View is an accidental time machine.

The real Half Cat was named Thumbelina. The photograph is from 2007. She (yes, time to update the default pronouns) was scurrying around the steps of Parliament Hill in Ottawa, Canada. If you Google "parliament hill Ottawa," the first autocomplete suggestion follows up with "shooting," referring to the fatal attack in front of the Centre Block parliament building. But back when Thumbelina wandered these steps, Google autocomplete might have suggested "parliament hill ottawa cat sanctuary." She was one of a number of strays that had a home in a corner with green-roofed, miniature wooden condos outside Parliament.

As early as 1924, there were cats working as mousers in the offices of Canadian politicians.[5] They later switched to chemical pest control, but groundskeepers and volunteers continued to take care of the cats that lived in the small shelters. In the eighties, a volunteer named Rene Chartrand, "the cat man," began building cold-weather shelters for the cats. His neighbor, Irène Desormeaux, had watched over these cats since the seventies. When she grew ill, he promised her that he would feed the cats. After she died in 1987, he kept his promise for twenty-one years. He retired in 2008, only after he could no longer make it up the hill.

Some of the cat houses he built were designed to look like the early European settlements along the St. Lawrence River. In 2003, there were as many as a few dozen cats living at the sanctuary. They would snuggle up together in the winter season to keep warm. That year, Chartrand was the recipient of the Humane Society of Canada's Heroes for Animals Award.[6]

Now another Google autocomplete I see is "parliament hill cats gone." The cat sanctuary's defunct blog says Thumbelina was adopted in 2008.[7] It also reports the last four cats found homes, and the sanctuary closed in January 2013 after decades of sheltering the feral cats. The volunteers decided to close the sanctuary because the remaining cats were getting old and growing sensitive to Ottawa's harsh winters. There was also construction around the grounds, and raccoons would often come to steal

the cats' food. It seemed like the right time to move on. Spaying and neutering had already reduced the number of cats to just a handful. According to the blog, the Parliament Hill cats did not "readily accept newcomers," and any cats abandoned at the sanctuary were always handed over to the Humane Society.

It's hard to imagine something as whimsical as the cat sanctuary having a home by the Capitol lawn on the National Mall, or livening up the tiny, decorous entrance to 10 Downing Street. A public servant at Ottawa's Parliamentary Library once told North Country Public Radio host Todd Moe, "There's nothing better than leaving a meeting, frustrated, and coming here and petting a cat! It makes the whole day better!"[8] Tourists were just as likely to visit Parliament Hill to see the cats as they were to go catch marching grenadiers in the Changing of the Guard ceremony.

Chartrand passed away in December 2014 at the age of ninety-two. The *Ottawa Citizen* remembered him first with the story, "When Parliament Hill was locked down after the 9/11 terror attacks, one of the few civilians allowed through the security cordon was René Chartrand."[9] Chartrand fed the cats on Christmas Day and New Year's Day. He showed up to care for the cats the day his wife died. He was there every day until he finally retired. The newspaper reports that, suffering from dementia, he never learned the cat sanctuary closed.

Parliament Hill isn't even captured by Street View cameras. Perhaps if Google Street View surveyed that area, it might have preserved the cat sanctuary full of felines, with coats of calico glitches and digital aberrations, as strange and native to the internet as Half Cat first appeared to us and with their "cat man" standing beside them. The real cat sanctuary lives on in Flickr sets and tourist-shot YouTube videos. It is on the internet, as if it never left.

Notes

1. Google-Street-View, Twitter post, May 6, 2013, 4:28 p.m., https://twitter.com/street viewfunny; Google Street View Guy, "New Cat Species Found on Google Street View," *Google Street View World* (blog), May 13, 2013, http://google-street-view.com/new-cat-species-found -on-google-street-view.

2. Max Read, "Where on Google Street View Can I Find This Wonderful Half Cat?" *Gawker* (blog), May 7, 2013, http://gawker.com/where-on-google-street-view-can-i-find -this-wonderful-h-494285679.

3. ipso, "What is the Dario Argento movie that has nested realities within reali-ties?" *Fluther* (blog), October 30, 2010, http://www.fluther.com/102385/what-is-the-dario -argento-movie-that-has-nested-realities-within.

4. WikiLeaks, Twitter post, September 6, 2012, 6:23 a.m., https://twitter.com/wikileaks /status/243670738899451905.

5. "Parliament Hill Cat Sanctuary Shutting down for Good," *CBC News*, January 4, 2013, http://www.cbc.ca/news/canada/ottawa/parliament-hill-cat-sanctuary-shutting-down-for-good -1.1304368.

6. Vanessa, "Cat Man of Parliament Hill," *Humane Society of Canada*, August 23, 2003, https:// www.humanesociety.com/pets/pet-info/905-cat-man-of-parliament-hill.html.

7. Klaus J. Gerken, "Home Page," *The Cats of Parliament Hill Blog*, last modified January 25, 2013, http://users.synapse.net/kgerken/CatsBlog.HTM.

8. Lucy Martin, "Remembering René Chartrand, 'catman' of Parliament Hill," *The In Box*, December 14, 2014, http://blogs.northcountrypublicradio.org/inbox/2014/12/14/remembering -rene-chartrand-catman-of-parliament-hill.

9. Blair Crawford, "Obituary: Parliament Hill's 'Catman' Tended Sanctuary for 21 Years," *Ottawa Citizen*, December 10, 2014, http://ottawacitizen.com/news/local-news/obituary -parliament-hills-catman-tended-sanctuary-for-21-years.

DAVID
CARR

CATS

I DON'T HATE ALL CATS. I like only one. Her name is Aligato.

Aligato is my neighbor's cat, and even though she craps in my yard as if she owned the joint, I've come to enjoy her charms.

She stays out late, she prowls. One of her eyes is either gone or permanently shut because, well, she's a bit of a brawler. When she does come on my porch, she always says hello and looks me right in the eye with her one good eye. She likes being petted, and she even comes when she is called. She is, in other words, a dog.

So my favorite cat—well, actually the only cat I like—is really a dog in a cat suit. The rest of them, the millions on the internet, at my friend's apartment in the city, in the cat lady's house up the street, I do not like. It's not that I hate them, it is only that I return their indifference. Cat owners lavish love on their pets and are convinced they are receiving something in return. What exactly are they getting back? A rub against the leg or hand? It means the cat has an itch, nothing more.

I asked Ben Huh, king of all internet cats and the dark overlord of I Can Has Cheezburger, why, with all of the tropes, memes, and wild critters on the web, that cats came to rule. He said it was very simple.

"The internet is a playpen for cats where you never have to smell or clean the litter box," he said.

But why love something that won't love you back, whether it is on the internet or in your home?

"Cats are like having a teenager. They just look at you over and over and say, 'Can I have more stuff?'" he said. "They don't really do anything; they lay about, so it's hard to tell cats apart from teenagers, except

teenagers hang out at malls more. And yet people still love their teenagers. And their cats."

I will admit that some of my best friends are, and there is no nice way to say this, cat people. My cousin Peg in fact sent me a T-shirt from the Walker's Internet Cat Video Festival, assuming I'd be happy to sport some cat wear. I love the Walker and the fact that I am from Minneapolis, and I love rocking a vintage T-shirt that suggests as much. But cat wear? Not. Going. To. Happen.

I have no intrinsic problem with the festival; it's just that even though I'm sure there are tons of normal, fun-loving Minnesotans at the event, if I spread out a blanket there, I would end up with the woman who had two scrawny cats on leashes, a stack of photos as thick as a deli sandwich of Sprinkles and Ms. Diva doing their thing, and a sweater with cats all over it, both knit into the garment and, in a less organized pattern of cat hair, all over it.

I'm not unmoved by the sight of a cat on the web playing the piano, but unless they are going to kick into a decent version of Chopin's First Ballade, op. 23, there is a going to be a limit to my amazement by this time.

Cat people can be nice people. A dear friend of mine lost his cat— the cat was old and led a very long and selfish life—and I felt terrible, but it was because I love my friend, not because I loved his cat. I tolerate my friend's cats the same way they tolerate me. We don't look at each other, and as long as we are not competing for the same food, we get along fine. It is only when a cat hops on a table—something a dog cannot and would not do—and begins snacking that I draw the line. A cat on the table is a deal breaker, more unappetizing than seeing the mouse scurrying in the corner that it refuses to go after.

All other domesticated animals that humans adore are working animals. It's a historical fact that cats were once prized for their ability to eliminate rodents, their one domestic chore, but most cats I know are on strike, content with being on the Meow Mix dole.

Cats were domesticated not for their usefulness, but because they were mooches and hung around humans, acting all cute and cuddly just for the snacks. Dogs save people, sniff out bombs, pull sleds, herd sheep, guide blind people. Cats are mostly good at finding a sunny spot in the apartment and doing a series of lazy stretches that would not pass

muster in a beginner's yoga class. On the internet, the cat's greatest hits usually show them doing stupid stuff involving aquariums, televisions, and mirrors, which aren't really tricks so much as cats expressing their inner aggression and narcissism.

Yes, in most developed countries there are more cats than children, but as soon as we figure out how to train a two-year-old to poop in a box and are able to leave them home alone for hours on end, you can bet those percentages will reverse.

Whenever cat lore comes up, their advocates will always mention that they were deified and mummified in Egypt, but let's remember that those pharaoh cat lovers enslaved thousands to build cats' pyramids, actual humans who were treated far less well. And throughout history, who were witches always hanging out with? Oh yeah, cats. The witch doesn't want a friendly labradoodle around; she wants a black cat as a like-minded familiar as she goes about her evil deeds.

In popular culture, the first icons that pop to my mind cat-wise are Garfield, Cat Woman, and Cat Stevens, all of whom have rather conflicted reputations. And who is the big star on the web these days in the feline world? Oh yeah, Grumpy Cat has six million likes on Facebook, all for her specialty of giving mean looks to everyone, which frankly doesn't strike me as remarkable—cats do that all the time.

I am not immune to the charms of the feline form. Cats, as the internet has taught us, are cute because they are both ferocious and adorable. They are predators rendered in miniature with all the tools of a killer—fangs, claws, a mighty pounce when they are not too fat—but they are harmless because of their size. That means that their hunting instincts are now aimed at rodents, hapless amphibians, and bugs. But make no mistake: when they dream, they dream large, of the days when they and their ancestors ruled the earth, loping along, scanning for food and hitting the afterburners when they saw prey.

And if those dreams came true, if evolution reversed and they again became big and ferocious, the relationship with humans would both change and, in some ways, be the same. When you come through the door at the end of the day, your cat sees one thing: food. It knows that it is time to eat, and you will obediently get its kibble and put some nasty wet food on top because, well, you are its slave.

If cats suddenly woke up saber-tooth size, they would still see food when you walked through the door, except you would be dinner. You don't like to dwell on it, but you know if they were big enough, they would snack on you as if you were a field mouse. They might toy with you a bit, letting you make a feckless attempt to flee before they gathered you back toward their hungry maw with a swipe of their paw.

Remember Timothy Treadwell, the guy who thought he was a friend to all grizzly bears in *Grizzly Man*? They were not his friends, as Werner Herzog, the director of the film, says in the narration. Looking at Treadwell's filmed footage of his bear friends, he says, "I discover no kinship, no understanding, no mercy. I see only the overwhelming indifference of nature. To me, there is no such thing as a secret world of the bears. And this blank stare speaks only of a half-bored interest in food."

There is no such thing as the secret world of cats, or if there is, they own you instead of the other way around. Be honest with yourself: How many times have you looked into your cat's eyes and seen not the wonders of the universe, but "a half-bored interest in food"? It'd eat you if it could, and seeing as it can't, it just stares at you until you come up with something they can.

All the anthropomorphizing and speculating you do about what is in your cat's little noggin? For naught. Your cat's brain weighs under an ounce, is the size of an avocado pit, and contains just as many deep thoughts. Cats have mastered the art of looking wise, but that uses up all the gray matter they have—which reminds me of a boss I once had, but that's a much longer story

Cats are different than us. You and I might hear a songbird and delight in God's creation. A cat will hear the same thing and do its best to kill and eat that bird, putting an end to the music and the creature that made it. Yes, they are expressing their inner, feral nature, but let's face it, any animal that will kill a pretty bird singing a song is pretty damn gangster.

My dog Charlie, a blonde lab and girl, by the way, chases squirrels, but does not catch them, a perfect version of the suburban wild kingdom. Every night she waits by the door and has a single question when I walk in: "Am I loving you enough right now?" She stares right into my face as she all but breaks herself in wagging with excitement. When she settles down and I ask

for a kiss, she will stop what she is doing—unless she is eating—and come over to me. She will look up at my face adoringly and slowly place one paw and then the other on my leg and hoist herself up and give me one delicate lick on the nose. And then she sits back down. When is the last time you saw a cat do that? Put that in your internet browser and smoke it.

You could say it is because my dog has no taste in companions, to which I would say, exactly. What I want in an animal companion is blind loyalty, unconditional love, and steady adoration. If I wanted another being to take me in with baleful indifference when I come home every night, I would have stayed married to my first wife.

So, in my family, we are dog people. That does not mean that if someone dropped a box of kittens on our doorstep we would ignore their mewling or their helpless adorableness. We would find a way to help them survive and find homes, but not ours, because kittens inevitably become cats, and that's where the problems begin.

My daughter Erin is an independent filmmaker and lives in Brooklyn, which is not code for unemployed and living off her rich father, because she does not have one. In Brooklyn, finding a place to live that you can afford is a war. Erin found such a place on the rougher side of Williamsburg, and she moved in with a guy she knew through friends. It is a nice apartment; she finds a way to meet the rent, but somewhere along the way, her room-mate picked up a cat named Latoya.

Latoya embodies all aspects of feline malevolence. She is a fat calico who hates everything, including my daughter, except yogurt, which she will stop at nothing to get a face full of if you try to eat it near her. She is mean because it is her nature, often walking into Erin's bedroom and staring her down as she takes a dump on the floor, or giving her a look over the shoulder as she pukes in the corner.

Like a lot of cats, Latoya sees ghosts everywhere, freaking out and clattering around when she spots some phantom menace. She does not like to be held and is skittish around everyone, including her owner. "When I look in her eyes, I see a reflection of all of the evil in the world," Erin recently told me. She and Latoya are in a Mexican standoff. Erin is not going to move, and Latoya is not going to change. Erin is a kind-hearted kid and would do nothing to harm Latoya, but she wishes Latoya would go for a stroll and never come back.

It is cheap and easy to use Latoya as a stand-in, like nominating an abandoned pit bull to represent all dogs, but when I see cats, I see Latoya. Perhaps she could have her own website where you could tune in, and she could return your digital gaze with a baleful stare 24/7. Grumpy Cat's agent could probably work with that.

I should say I don't mind looking at cats on the internet, in part because they are ubiquitous and can't be avoided, and in part because I think that's where cats should live, on the internet, imprisoned by my browser and one click away from being banished.

So, my little furry friends, go forth and multiply. Infest every corner of the web as is your nature. Chase that laser light, squeeze yourself into a glass bowl, freak out at the toy robot that your owner has set before you. YouTube is waiting, and people imprisoned in office cubes everywhere depend on you, cats of the internet, to bring a moment of respite to the quotidian tasks that are on other applications minimized until the boss walks by.

We will continue to click because it is in our nature. We might even organize a film festival at a cutting-edge museum so that your splendors, your unique charms, can finally find the wide-screen presentation and communal audience your charms deserve. But if we meet offline in the real world, don't expect me to ask for an autograph. I've interviewed and written dozens of stories about famous people who are riveting on-screen. They are, with very few exceptions, a huge disappointment IRL. And some are monsters, drunk on narcissism and transfixed by their own reflection in the faces of those who adore them.

You, cats of the internet, may be hilarious and full of frolic when the camera is on, but once the lights go down and the set is struck, you are still a cat. I know who and what you are. As do you, Mr. Cat. Just don't tell the others, and you will be fine.

STEPHEN
BURT

PROLEGOMENA TO
ANY FUTURE POETICS
OF THE CAT VIDEO

"As an extra, a surplus, a hiatus even, form is conceived by the cat video as a pause in the work of signification, which also alters the nature of signification.... The cat video suggests that form stops us in our tracks of thinking, and inserts itself in that moment of stillness. To attend to form is thus to admit some other kind of mental attention."[1]

"Le chat pour le chat, sans but, car tout but dénature le chat."[2]

"The importance of not being in earnest is precisely what makes the play of the cat video important."[3]

"It is not the cat video's place to ask you to learn.... Any cat who wants your particular admiration is, by just so much, the less cat."[4]

"In this inner diversity of the cat video, therefore, we have renewed proof that it is essentially a game, a contract valid within circumscribed limits, serving no useful purpose but yielding pleasure, relaxation, and an elevation of spirit.... And it is precisely its play-quality that makes its laws more rigorous than those of any other art."[5]

"If I agree to judge a cat video according to pleasure, I cannot go on to say: this one is good, that bad.... The cat video (the same is true of the singing voice) can wring from me only this judgment, in no way adjectival: *that's it!*"[6]

"A cat video holds its own and remains unintimidated by the analytic zeal that Hegel ascribes to the Understanding. . . . The cat

video holds its secret by allowing us to divine that it has one. I see no reason why it should yield to the analytic pressure of the Understanding: each has its own privileged way of acting in the world."[7]

"For the cat video comes to you proposing frankly to give nothing but the highest quality to your moments as they pass, and simply for those moments' sake."[8]

ALL THESE QUOTATIONS FROM CRITICS, philosophers, and poets—you may recognize a couple of them—have been changed. I have replaced a key word with "cat" or "cat video." (You can find the original words at the end of this essay.) In each case, the sentence appears to hold just as much truth. And the reason is this: Cats in general, and cat videos in particular, appear to test, and sometimes to confirm, familiar ideas about the essence of art. In particular, they test the set of ideas we are used to calling aestheticism (as explored, most recently, in Angela Leighton's terrific book *On Form*). Cats, like art, are serious play, beyond purpose, promising us a way into another order, an escape from the practicalities of this world.

Cats; not other pets, nor wild creatures, or at least not to the same extent. "Cats . . . pursue their own agenda, they cannot be relied upon to share our feelings, their minds are less open to us, and they seem quite immune to human or canine guilt," writes Katharine Rogers in *The Cat and the Human Imagination*. "Seeing them as essentially different from ourselves, we are better able to appreciate their qualities, and we even idealize them for the self-assured independence and the freedom from inhibitions that we feel we should restrain in ourselves."[9] Like John Keats's urn, that "friend to man," they imitate human action without depending on it, and they befriend us by staying distant from whatever we want for them or for ourselves. Like the urn, they suggest timelessness, even perfection.

Cats have purposiveness without a knowable purpose (Immanuel Kant's much-cited criterion for true art). Cats are mysteries; their agendas, beyond food and sleep and sunlight, may constitute a kind of knowledge endlessly deferred. (They are born aesthetes, but also born deconstructionists.) All cats, writes Charles Baudelaire in "Les Chats," partake of the ineffable, indecipherable "noble attitudes" of the sphinx, at least when they

dream; and no human being knows what they dream. Without trying—for cats there is no try, just do or do not—cats seem to instantiate the criteria of the aesthetic, so that to defend the aesthetic is to defend the feline, or vice versa. Cats are like serious art.

But cat videos are not, quite. The genius of the cat video may be the way it combines the essence of cat—its mysteriousness; its purposelessness without purpose; its sense that cats neither make, nor acknowledge, mistakes; its existence as beauty in itself and for itself—with the opposite of that essence. Cat videos are antithetical to cats' being in that so many of them show clearly fallible cats pursuing some clear goal—to grab string, to climb a high shelf, to ride a Roomba. (Do check out the Roomba.) They invert cats' inviolable indifference: They undercut their subjects (sometimes literally) as farce and broad comedy almost always do. They show that the cat (as Auden writes of Yeats) might be "silly like us."

And like all broad comedy, they highlight failure. The cat herself, or himself, maintains a mystery, believes in her own mystery, whether or not we do. But the cat of the cat video undermines that mystery by taking ridiculously comprehensible action (its intelligibility reinforced, at times, by subtitles or title cards, as in a silent film). The cat video at its best, moreover, must contain both extraordinarily dignified and remarkably graceless elements: the gray-and-white monument, the longhair in her majesty, the mountain of fur, eyes glaring as if to repel the gods themselves, accompanied by the caption, "I peed in the sink."

Why not dog videos? Dogs are too much like us (too obviously silly like us): Their purposes are almost never mysterious, and so there is nothing paradoxical, often not even remarkable, when they fail. And dogs' failures shame them; laugh, and we shame ourselves. Cats don't care whether we laugh at their failures, which stops us feeling guilty when we do. Rogers adduces not only Baudelaire but H. P. Lovecraft, whose essay on felinity "expressed his disgust with society through a contrast between feline independence and canine need to conform."[10] The contrarian poet and the defiantly loutish fictioneer unite in their sense that their art should be catlike, that cats' independence is part of what makes them fascinating (rather than useful or morally good). That same independence licenses us (especially if we are—as Baudelaire was not—kindly disposed toward our peers' ethics) to laugh when cats fail to do something on their own. As

for internet videos of what veterinarians call exotics—ferrets, hedgehogs, chinchillas, quintorcoups—they tend to show these admittedly super-cute mammals simply being themselves, twitching, puckering, cuddling: they do not try to do odd things and so do not fail—if they do, they count as honorary cats.

Then there are LOLcats, which need not be cats: The best—the epic—use of LOLcat style so far is the Walrus Bucket Saga, 140 gifs (most from 2008–2010) that began with a two-photo shot of a zookeeper and a walrus: "I Has a Bucket," says one; "Noooo they be stealin' my Bucket," complains the other. Successive pictures—crowdsourced and still being made—follow the walrus's fruitless quest for his lost bucket all over teh worldz. A polar bear embraces a walrus on the beach: "Hugz? Won't Bring Back Bukket!!!" Walrus on an ice floe: "I is lonly widdout bukkit." Walrus nuzzling, or speaking secrets into the ear of, another walrus: "Pleez find mah bukkit ur mah only hope."

What the Walrus Bucket Saga tells us about cat videos is this: We are all on a quest for something pointless, something empty in itself, as the walrus's bucket was empty. Someday it may again hold tasty fish, but for now, it is Stevens's jar, Keats's urn, the inner life of the sphinx, a thing desired, but empty and outside time. Moreover, our quest—our need for purpose, our need to jump up a wall chasing a laser pointer—precedes any acknowledged goal or education; we want what we want even when we do not know quite what we want, and certainly before we know why we want it. The walrus is like a preschooler in this respect, but also like all of us, and preeminently like cats; the appellation "lolrus"—walrus + LOLcat—reminds us who came first. And if the Walrus Bucket Saga reminds us how much we might want what is finally empty, the fifty-nine-second video called "Kido's First Shell Game" reminds us—as all cat videos remind us—that we are also free to refuse: Kido simply does not care what's under, in, or around the big thimbles that her owner picks up and puts down. She exists outside human purpose, outside her owner's time.

If, as many of us can confirm, the internet is 90 percent porn and 9.5 percent cats, and if—this part is true by definition—porn has a purpose (to get someone off), then 95 percent of the non-porn internet offers a refuge from the relentless purposiveness of modern life, where we have goals and seek the shortest means to those goals, either at work or amid

the NSFW. But cat videos are neither work, nor are they NSFW, not even for most of their human creators. Even more than punk rock, scrimshaw, macramé, or conventional lyric poetry, cat videos are made by people who do not expect to make a living from the form. The merch may cost you, but the screen time is always free.

That is one reason why the *Simon's Cat* videos, terrific as they are, are not really cat videos; they are the cartoonist Simon Tofield's beautiful and diligent exercise of his vocation, which he was lucky enough to make into a financially sustaining profession; they could exist even if Simon Tofield had never owned a cat. The presence of advertising banners and intertitles on cat videos, however, can augment their greatness, rather than change their status: thirty seconds of someone caressing a kitten's ears, twenty seconds of the same silver kitten parading pointlessly over the crowded top of somebody's fridge, get better—defy human purposes more completely—when we encounter them over a sans-serif, all-caps banner reading, "LEADERSHIP IS NOT OPTIONAL." Clearly, if you're a cat, leadership is optional: if you're a cat, in fact, everything is optional, except for obedience to your own fathomless nature, which compels you to undertake activities that human beings can understand only as play.

Cats do all sorts of things—and many sorts of nothing—in cat videos, but perhaps the most common is stalking. The tabby paces warily around an innocuous object at a distance of, say, three feet, and then spirals in for the pounce (or for the failed pounce). The nightstand then topples sideways, taking the cat and the hat, pen, or shoelace with it; or, in an entirely successful pounce, the cat appears to realize after the fact that the shoelace or pear core cannot be cat food. Pounce videos work when the cat chooses, herself, to pounce—it's less funny when there's a cat toy (say, a fishing rod), and they don't work at all if the object pounced upon is alive and can feel pain. However, when a cat seems to choose to stalk a thing the cat should know can't be food, the cat obeys her inner laws—acts out her mystery—and what we see is the fulfillment of her nature in a way that seems incongruous to ours. Conversely, cats cuddling with animals that could have become their food (but now, we gather, are safe from being eaten) make good cat videos; again, we know what the cat has tried to do, what the cat has decided to do, but not why.

There is a taxonomy of cat videos, just as there is a taxonomy of anything that is, or is like, an art form. There are minimalist cat videos, in which the Manx simply blinx; there are pratfalls (cat jumps off a roof, cat falls out of the cabinet); there are attempts to fit into too small a space; there are meetings with other kinds of cute animals; there is the pounce (see above); there are meetings with water (apparent disasters, though we can be sure the cats ended up dry and fine); there are videos and photomontages in which human beings wear cats as clothes; and there are videos in which cats do cat things while dressed up as (or riding on top, or pretending to be) something else—"Cat in a Shark Costume Chases a Duck While Riding a Roomba," for example, the turducken of cat videos, or perhaps the Salome. This last category— perhaps the most important (along with the pounce)—reminds us that the behavior in cat videos is at once totally "natural" (no one told the cats to be that way) and obviously, flagrantly, artificial. Cats do as they like, but the frames we place around their actions, and the electric-blue, toothy, plush shark heads, are ours.

There is no entry for "cats" in the index to Sianne Ngai's magnificently provocative study *Our Aesthetic Categories*, but there should be: All three of Ngai's contemporary categories—the zany, the cute, and the merely interesting—apply to cat videos, as the so frequently studied, older categories of the purely beautiful, the sublime, the erotically attractive, and the instrumentally useful do not. Cats are (as Rogers says) by default feminine and domestic and smaller than people, which makes them cute. They circulate on the internet because we forward them and click on them, which makes them (almost by definition) interesting. And they parody our own attempts to complete our human tasks, so that their disproportion of effort and result (and the resulting slapstick) makes them—with their "image of dangerously strenuous activity"—zany.[12] The zany cat falls off the roof; he tried hard to stay on. The zany worker in silent film falls off the roof, or out of the social safety net. Both are modern. Both are also Chaplinesque—and Hart Crane's "Chaplinesque," as some of you know, concludes with "a kitten in the wilderness," one who perhaps grows up to read cummings and Don Marquis, survives the crash of 1929, and becomes the world's oldest LOLcat. For Marianne Moore's friend's cat, Peter, in her modernist poem "Peter":

It

is permissible to choose one's employment, to abandon the wire nail, the
roly-poly, when it shows signs of being no longer a pleas

ure, to score the adjacent magazine with a double line of strokes. He can
talk, but insolently says nothing. What of it? When one is frank, one's very
presence is a compliment.[13]

This cat wants to be in a video, but he cannot be; he is free, unattached,
above laughter, uncompromised.

Cat videos have no consequence; they do not matter; they are pure
form, as their stars seem inconsequential, pursuers of form or else natural
artists of instinct. They do not appear to be work and do not depict work,
even though they took work, and luck, to create; they are impractical, silly
even, and they promote the impractical as we watch them, taking us away
from the insistent demands of instrumental reason, of economic exchange
and exchange value, even if (as with the merchandising of *Henri, le Chat
Noir*, or the fact that some people buy books of poetry) we later return to
economic models of exchange as we pursue the art.

Because cats do not tell us what they want—unless what they want is
banal (warmth, water, food, catnip)—we assume they have mysterious pur-
poses and that they often succeed; but a standard cat video plot shows a
cat's epic fail, which also swipes the mystery away, like the curtain that lifts
on the Wizard of Oz. At the same time, the task at which the cat fails may
seem pointless to human beings. Why is that giant Siamese trying so hard
to enter that tiny box? Why does that Maine coon cat believe she can fit in
the sink? It is purposelessness without purpose—but it is also a purpose
shown, and not achieved.

Cat videos thus both present and parody central features of art, of the
aesthetic, as we have been taught to consider it, especially but not only in
prestige venues (museums, not rec rooms; the *Norton Anthology*, not Archive
of Our Own) indebted to Romantic or Kantian concepts of art qua art. If
we're willing to defend any of those concepts, are we troubled by the extent
to which the same defenses (play, purposelessness, escape from exchange
value, freedom from instrumentality, purity, mystery, harmony with animal
instincts) apply to cat videos? If we're not troubled, should we be?

Cat videos, like high art, are for nothing, do nothing, "make nothing happen," embody both a kind of passive reception and a spirit of play. In so doing, they show the thin line between an art that takes us out of this world, for play, and an art that cannot justify itself, a nihilism that cannot speak its name. (High art, as those of us who love it actually use and experience it, may be a lot more like fan fiction than most of us realize, but that is an argument for another place: see Anne Jamison's *Fic: Why Fanfiction Is Taking Over the World* if you would like to visit that place.)

Which brings us (via Leighton, whose claims I have been tacitly following) to a particularly thoughtful cat, Henri, le Chat Noir. Henri's seriousness, a seriousness we associate both with Frenchness and with art in one sense, plays against the frivolity, the pointlessness, the end-in-itself-ness both of cats (who have no purpose beyond themselves) and of cat videos (which do nothing but entertain). Henri's seriousness lets him *see through* the false, futile purposes adopted by human beings and less knowing cats: "the humans brush us for their own vanity," to "no real purpose whatsoever." Henri's clichés come from the France of the postwar, of Camus and Sartre, of absurdism and existentialism, which tell us that we have no given purpose: we must make one for ourselves.

Except, of course, that Henri's purpose appears to be nothing more than to be in a cat video, telling us that we have nothing better to do, and that our lives have no higher purpose than his. This live Henri of the videos (videos which also look back to Monty Python's parodies of Continental art film) takes his name from a famous poster of the 1890s. But the chat noir of that poster appears at home in his stylized element, insusceptible to the anomie and the bad surprise that afflicts both Henri the cat video cat (who discovers shaving cream is not whipped cream) and us, if we spend too long watching cat videos. The time-wasting delight of contemplating art, especially art that doesn't ask much from us, is only a cat whisker or two away from the anomie and the self-accusation of realizing we have whiled hours away on nothing. Cat videos—especially the finest of the lot—show that the "self-forgetful, perfectly useless concentration" Elizabeth Bishop describes in the making of art (and that we might find ourselves contemplating in cats!) is only one notch away from a waste of time.

Notes and Key to Replaced Words

1. Angela Leighton, *On Form: Poetry, Aestheticism, and the Legacy of a Word* (Oxford: Oxford University Press, 2007), 20–21 (cat video = Barthes).

2. Benjamin Constant, 1804, quoted in Leighton, 32 (le chat = l'art).

3. Leighton, *On Form*, 36 (cat video = literature).

4. Ezra Pound, "The Serious Artist," in *Literary Essays of Ezra Pound* (Norfolk, CT: New Directions, 1954), 41–57 (cat video = artist; cat = artist).

5. Johan Huizinga, *Homo Ludens*, trans. anonymous (Boston: Beacon, 1950), 188 (cat video = music).

6. Roland Barthes, *The Pleasure of the Text*, trans. Richard Miller (New York: Hill and Wang, 1975), 13 (cat video = text).

7. Denis Donoghue, *Speaking of Beauty* (New Haven: Yale University Press, 2003), 24–25 (cat video = beautiful thing).

8. Walter Pater, *The Renaissance: Studies in Art and Poetry* (Mineola, NY: Dover Publications, 2005), 155 (cat video = art).

9. Katharine Rogers, *The Cat and the Human Imagination* (Ann Arbor: University of Michigan Press, 1998), 3.

10. Ibid., 147.

11. Sianne Ngai, *Our Aesthetic Categories: Zany, Cute, Interesting* (Cambridge, MA: Harvard University Press, 2012), 8.

SARAH
SCHULTZ

THERE WAS A CAT
VIDEO FESTIVAL IN
MINNEAPOLIS, AND IT
WAS GLORIOUS

ON A WARM AUGUST EVENING IN MINNEAPOLIS, Minnesota, under the brilliant light of a rare blue moon, a crowd gathered on a grassy hill next to the Walker Art Center. A prominent contemporary art museum, the Walker is known for cutting-edge and challenging exhibitions and for risk-taking experiments in performing arts, film, design, and new media. It also hosts events like rock concerts, outdoor film screenings, and family fun days, so it wasn't unusual to see people converging on the field. But this was different. A weird mixture of anticipation and curiosity hung in the air. Perhaps it was the deep vibrations of the media activity that had been building for weeks. Perhaps it was simply our northern need to squeeze every moment out of a waning summer.

Whatever the reasons, people came from all over, not just from the Twin Cities of Minneapolis and Saint Paul. They drove in from Wisconsin and Iowa and flew in from New York and California. They arrived with blankets and coolers; in pairs, alone, and as families. They were retirees and hipsters. They sported cat ears, cat tattoos, and full feline regalia. Some brought their cats. Some chose this as the first offline meeting of online friends. And they kept arriving, nestling on the lawn, standing on the edges of the field, craning their necks to see, until there were ten thousand of them, spilling out into the streets, stopping traffic on nearby freeways. It was as if the internet had cracked open and spilled out, adorned in fake fur, whiskers, and adorable T-shirts. For seventy joy-filled minutes, we sat together, watching cats jump into boxes, play keyboards, and offer existential musings at CatVidFest, the first Internet Cat Video Festival.

You love them. You mock them. But one thing you can't do is stop watching them.

Yes, we're talking about internet cat videos. Which either represent the pinnacle of human creative achievement, or a sign that the apocalypse is nigh. Or both.[1]

An internet cat video festival is one of those things that seems so self-evident you can't imagine a time when it didn't exist, much like the internet itself. But until that August night, if you were a cat-video fan, you were probably indulging this interest alone, killing time at work, at home in your pajamas, posting links to Facebook or taking a Buzzfeed survey to see which Tender Vittles you prefer.

The brilliant and fated idea to screen internet cat videos on the lawn of the Walker was that of my colleague Katie Hill. Consider Katie a next-generation cat lady—young; obsessively devoted to her adopted domestic shorthair tabbies, Max and Ron; and armed with the technology to unabashedly share that love, as in #catlady4eva, #caturday, #catstagram. Her feline love was no secret to her colleagues in the Walker's Education and Community Programs Department. Katie had been harboring the idea for a festival for months, inspired by Chat D'Oeuvres, a cat-themed film festival at New York's Anthology Film Archives. Originally conceived as a home screening for friends, she declared her larger curatorial aspirations in a Walker blog post. What enabled Katie's wish to be realized by an internationally renowned contemporary art center was help from her colleagues, notably Scott Stulen (who loves the internet the way Katie loves cats), and the serendipitous convergence of the right time, the right place, and an unusual museum platform called Open Field.

Open Field is an experiment dreamed up in the museum's Education and Community Programs Department that transformed a green space adjacent to the galleries into a cultural commons—a collaborative platform for artists, the public, and the museum to jointly program and share. Through a diverse mixture of crowdsourced and curated activities, the spirit of Open Field is to question aesthetic hierarchies, imagine new social and civic roles for the museum, and create a new kind of public

forum or park with the public. We used it to explore cultural democracy in the age of the internet, an intentional mash-up of "high" and "low" cultural forms that was described by one local writer as a "happy mutant smorgasbord."[2] So cat videos were not peculiar or quirky in a space that had hosted everything from classes on aesthetics to bull-whipping lessons, yoga, and an attempt to break the Guinness World Record for longest continuous applause (which, for the record, we did).

Of these hundreds of social and creative experiments on Open Field, CatVidFest stood out not in intent, but in size, scale, and media attention. At its core, it was a sincere gesture and simple test to see if the solitary act of watching cat videos on a computer screen would translate into something different as a collective physical experience. Would anyone LOL IRL and come to watch cat videos they could more easily view with a few clicks at home? How would this solo hobby translate to a public setting? What would it mean for a cultural institution to forgo an ironic or critical position around something so blatantly populist? How would people respond to an internet cat video festival put on with complete sincerity, enthusiasm, and celebration?

> You can nominate your cat video of choice over here, but keep in mind that, in doing so, you will be actively precipitating the down-fall of modern society. Just a heads up.[3]

Yes, yes. Cats rule the internet in the same the way they wield mysterious control over their owners. Still, we were unprepared for how fast and hard the attention came. The first was from the *Los Angeles Times* just hours after the official announcement. *Gawker* picked up the story, and it spread across the internet over the next forty-eight hours like a cat in shark suit on a Roomba chasing a duck. The calls came from places as far flung as Kansas, Chicago, Brazil, and Australia. Major media, radio and television shows, blogs, college papers, and cat media (it turns out there is such a thing) were all hooked.

The strangeness of an art museum being the first to host such a festival was an irresistible narrative. The media wanted to know how we had come up with idea, if cat videos were art, and how many people we thought

would show up. They asked about the names of Katie's cats and how many videos she had watched. Some reporters were mocking, some were celebratory, and some were after clickbait. Most, however, were curious and enthusiastic, trying to make sense of it all, and virtually no one could resist the purrfect opportunity for puns.

When entries opened on July 8, we were deluged with excitement. "It's about time!" "So many cat videos. Not enough nomination forms!" The rules were simple, and submissions grew exponentially. First thirty, then three hundred, then three thousand, and within weeks more than ten thousand. It was dumbfounding. We received letters, e-mails, phone calls, VHS tapes of cats, and all manner of cat-themed stuff as gifts or possible bribes. Filmmakers and cat agents tried to strong-arm us to include their work. People wrote Katie with their personal cat stories. Someone from Singapore sent her a hand-carved cat sculpture. We were all living our fifteen minutes of fame.

Cultural democracy is messy, and crowdsourcing benefits from an editor. We watched *a lot* of cat videos, with friends serving as "official" jurors to weed out the duplicates and find undiscovered gems. Katie claims she watched them all. Working closely with the museum's videographer, Katie and Scott edited, trimmed, and sequenced eighty-five videos into a tightly curated, seventy-minute reel. We added coherence by riffing on traditional film festivals with "cat-agories" like Comedy, Drama, Foreign, Documentary, Animated, Musical, Art House, and Lifetime Achievement. There was even a public vote for the Golden Kitty, a cross between an Oscar, a People's Choice Award, and Best in Show. Our designers created branded graphics, T-shirts, and a special #catvidfest logo, and surprised us by "catifying" the Walker's website on festival day.

We know what you're thinking: Why am I not in Minneapolis right now at the first Internet Cat Video Festival watching the best clips of cats chasing laser pointers, purring and ignoring the camera?[4]

Despite the buzz, no one knew what would actually happen. Unknowingly, the Internet Cat Video Festival was scheduled to go up against another big

night in entertainment: Mitt Romney (and Clint Eastwood and Chair) at the Republican National Convention. But thoughts of that were far away as we made watercooler bets about attendance and scrambled to bring in a larger screen. We invited a band for the preshow (they played Cat Stevens). Seattle native Will Braden, the creator of the popular *Henri, le Chat Noir* series, bought his plane ticket before he even knew he was included in the fest, only to win the Golden Kitty and fortuitously be on hand to personally accept it (it being a hastily constructed Japanese maneki-neko cat figurine glued to a small trophy base). Reporters flew in from the *New York Times*, *Slate*, *VICE*, *Jezebel*, and the *Atlantic*. Lil BUB, the celebrity permakitten from Indiana, arrived. While crowds gathered around her and her tattooed owner, Mike Bridavsky, Katie and I experienced a different unexpected celebrity crush: Maddie Kelly, the child star of *Kittens Inspired by Kittens* (hands down the best cat video ever!), lived right under our noses in a nearby suburb and had just showed up. We fell over ourselves to get our photos taken. Social media gold.

When the time came, Katie and Scott found themselves behind the screen watching the reel in reverse. Would it please their audience? As the screen lit up the faces of the crowd, they heard collective laughter and "awws" and shout-outs to favorite clips. It was a complete affirmation that this creature of a project had captured something unexpected and special.

The Internet Cat Video Festival was one of the most joyful, sincere, and unexpected projects to come out of Open Field, and one of the best attended and widely covered events in the history of the Walker. The *New York Times* featured it above the fold, calling the festival "an online meme made flesh (and fur)."[5] Madeline Davis, a writer for *Jezebel*, admitted that she came to the festival to mock us Midwestern cat lovers and found something else entirely:

> The Internet Cat Video Festival made an act of isolation (sitting alone in front of our computer screen) into a celebration of togetherness. Walking toward the parking ramp, I noticed that people who were previously strangers were now interacting with ease. Cars were letting other cars pull ahead of them. Everyone was happy and being kind. While my bones ached from standing and my head hurt from exhaustion, I was sad to leave the small utopia that the Walker had created.[6]

Why do cat videos have the power to draw so many people together? Ben Huh of I Can Has Cheezburger fame says it well: "Before the internet, cat people didn't have a place to socialize. Dog owners had the dog park."[7] The festival was the ultimate feline lovers meet-up, a way for a disembodied cat community to come together, commune, and celebrate. For some skeptics, it was curiosity, a had-to-see-to-believe moment. For others, a cat night at a contemporary art museum may have been a permission slip for their public enjoyment of a guilty pleasure or dressing up as their pet. For all of us it was, well, a lot of fun.

The Walker is an actual, important museum. I don't know how I'm supposed to feel about this.[8]

That evening on the lawn spawned something unexpectedly larger. Following requests to restage the event, we launched a festival tour that has traveled from Fargo to Perth and seventy cities in between. It has screened in museums, theaters, tech conferences, a punk club, and even on a castle wall. Scott cannily saw an opportunity to appeal to internet cat fandom and brokered the first IRL meeting of online feline goddesses Lil BUB and Grumpy Cat on the Grandstand Stage of the Minnesota State Fair to a crowd of twelve thousand people. What we thought was a lark turned out to be a global happening with a very long tail.

Along with all the excitement and unabashed enthusiasm, there was also uneasiness and bafflement from some. While many of my colleagues went along for the ride, others displayed pained tolerance, embarrassment, and a bit of jealousy about the massive amount of attention this event was getting. The strange thing about this response is that the Walker, like every other cultural institution seeking to expand its audience, engages in populist activities all the time, from beer tastings to an annual miniature golf course. It even sells branded coffee, Catalyst, although I don't think the pun was intended.

Museums confer meaning and value by collecting and displaying things and, more importantly, by giving them context. They are among the few places where we can focus, pause, and consider the complexity

and joy in the things we create. As someone who has spent a career inside museums, I understand the concern that by giving people cats, we may raise the expectation that everything we do is easily digestible. But I disagree with the insinuation that we were "dumbing down" the institution and turning people away from the more serious and challenging demands and pleasures of art. Reciprocity goes a long way in any relationship—show me your cat videos, and I'll show you my conceptual art. People have idiosyncratic tastes, and they always have; the internet just allows us to indulge them more freely. Cultural institutions should embrace divergent and seemingly contradictory aesthetics and practices. We need our museums to help us contextualize a content-saturated world. Questioning rather than imposing what is worthy of our attention can only give us a richer experience of who we are and who we might want to become. And sometimes museums just need to lighten up and have some fun.

We are social creatures. CatVidFest's popularity says a lot about some very basic human needs and the ways in which cultures fulfill those needs. Our technologies reinforce and empower those desires. Think about the verbs that dominate our digital lives: link, share, endorse, connect, like, and even tweet, adopted from the communication habits of birds. But as more of our lives are lived online, we also become hungry for moments of physical human connection. It's why we go to coffee shops, hang out in bars, still shop at malls, live in cities, attend concerts and sporting events, and go to museums with friends. I will confess that I don't have a cat, or any pet for that matter; until I got embroiled in this festival, I had only watched "Keyboard Cat" and "Surprised Kitty." So you can imagine my own surprise in how events unfolded and the unexpected kinship I discovered in riding the wave of other people's enthusiasm and delight.

The Internet Cat Video Festival, with its sincerity, populism, cuteness, and frivolity, ran against every sentiment one normally associates with the art world. And maybe the art world doesn't want to take cat videos seriously, but they should take the people who watch them seriously, even if they are wearing pink bathrobes festooned with toy kittens. After all, it isn't about watching cat videos. It is about watching cat videos *together*.

Notes

I would like to thank Kristina Fong, Katie Hill, and Scott Stulen for their contributions to this essay.

1. Chris O'Brien, "Oakland hosts 2nd Internet Cat Video Festival (and Grumpy Cat, too)," *Los Angeles Times*, May 11, 2013, http://articles.latimes.com/2013/may/11/business/la-fi-tn
-oakland-internet-cat-video-festival-20130510.

2. Maggie Koerth-Baker, "Minneapolis: Home of the first (annual?) Internet cat video film festival," *Boing Boing*, July 12, 2012, http://boingboing.net/2012/07/12/minneapolis-home
-of-the-first.html.

3. Neetzan Zimmerman, "And So It Begins: Internet Cat Video Film Festival to Take Place Next Month in Minneapolis," *Gawker* (blog), July 21, 2012, http://gawker.com/5924892
/and-so-it-begins-internet-cat-video-film-festival-to-take-place-next-month-in-minneapolis.

4. Zoe Fox, "Internet Cat Video Film Festival Underway in Minnesota," *Mashable*, August 30, 2012, http://mashable.com/2012/08/30/internet-cat-video-film-festival.

5. Melena Ryzik, "At Cat Video Festival, Stars Purr for Close-Ups," *New York Times*, August 31, 2012, http://www.nytimes.com/2012/09/01/movies/at-cat-video-film-festival-stars-purr-for-close
-ups.html?_r=0.

6. Madeline Davis, "I Went Looking For Internet Cat Freaks, But Instead I Found Myself," *Jezebel* (blog), September 11, 2012, http://jezebel.com/5939801/i-went-looking-for
-internet-cat-freaks-but-instead-i-found-myself.

7. Barbara Herman, "Ben Huh Interview: Meet The Cat Philosopher Behind 'I Can Has Cheezburger?'" *International Business Times*, November 3, 2014, http://www.ibtimes.com
/ben-huh-interview-meet-cat-philosopher-behind-i-can-has-cheezburger-1716449.

8. Moribundbundy, July 10, 2012, 8:04 p.m., comment on Zimmerman, "And So It Begins."

LITERATURE
is not the same thing as
PUBLISHING

Coffee House Press began as a small letterpress operation in 1972 and has grown into an internationally renowned non-profit publisher of literary fiction, essays, poetry, and other work that doesn't fit neatly into genre categories.

Coffee House Press is both a publisher and an arts organization. Through our *Books in Action* program and publications, we've become interdisciplinary collaborators and incubators for new work and audience experiences. Our vision for the future is one where a publisher is a catalyst and connector.

THANK YOU, CATSTARTERS!

Amanda Bullock Jason Diamond Steph Opitz Megan Lynch Jen McNitt Julian Higuerey Nunez Lynda Tysdal Kevin Nguyen Tobias Carroll Kathleen Brennan Ami Greko Fiep and Mellow Kristina Fong David Sagstad Bonnie Russ Rebekkah Dworski Optimus P. Musich Jessie Faust Juliana Wright Sharon M. Anderson Nicole He William Herrmann Sarah Crocker Kathleen Bergan Schmidt Francine Knight Ander Monson Caitlyn Ruen Scott Stulen Jon Westmark Wendy Contreras Terri Ottosen Nan Holcomb Carolyn Hawkins *Henna* Erin Kersh Andy Sturdevant Martha and Bill Bonwitt Clea Simon Strummer Enid Jazz Pau-

lis Kathy O. Jason Summerlott Brown Kristen Verdeaux Rachel J. MacKay Kevin Shannon Ruth Blake Kuhre Emily Kissane Gene and Benjamin Imker Ashley Duffa-Patane Victoria Breshears Anna er Deirdre Crimmins Mary Jones lis Lacey N. Dunham Colin Dickey Lights.mn Shelley Harper Chris Erin Davis Emi's Good Eating Jade Rebecca Elder Sarah Sime Martha Winter Samuel Henson Rachel Korn-Hartman Andy DuCett Inara Ver-Mann Dregam Erin Maurelli Ed-Yancey Strickler Veronica K. Carpenter Casey Gunn Alison Amanda Gullickson Fred Ben-san Michals Travis Greenwood Rotunno Mona Shahgholi ban Christy Tidwell Jean Shea frey Karen Rachel Knickmeyer EC Pulford Olivier Gazzera Heilman Hannah Frick Susan Lisa August Heid Erdrich Kate Higgins Clydene Nee Rozsi ney Ortman Sarah Caflisch halski Ava Szychalski Anne Enyeart Caroline Button Carpenter Krista Rose David Ritter Sheila Varsakis Sebas-"Meow" Prager jamin Sutton Kinney Adri-of Cats and Lisa Lucas Lin-jamin Rybeck Nancy Fong Cynthia Mari ryn Koutsky Kel-son Chris Jansen Maria Mortati Cather-B. Joe Turkel Greg Lavine Brenna McLaughlin kate alcid en Switzer Claire and Alan Rose Carol La Jess Ferguson Sara Langworthy Kathy Gabriele Koecher Barbara Blauman Gay-Wegner Laurie Ann Tuttle Steven Horwitz Anne Talvaz O'Reilly Sarah Pickup-Diligenti Melissa Evans Edward Casey Me-Bonino Sue Michalka Andrea Satter Roger and Janis Fischbach Mark Kubo Debbie Elven-Snyder Colleen A. Kelly Lisa Horwitz Steven Lindquist Shana R. Lighter Kristin Thiel Sandra Howerton John Barhydt Jeffrey Sugerman Olga Viso Katarzyna Sornat Carolyn Taylor

Grover Glenn Kathleen Gardiner Priscilla English kateblu Andrea Riederer Alex Wiles Emily Hughes Valerie Verner Diana Piggott Liam Curry Ethan Marxhausen Lauren Fries Betsy Lien Justin de Nooijer Bird Lindsay Stern Sarah Peters Katie and Chris Kallmyer Curt Lund lo Shawn Wen John Capecci Jamie Schwesnedl Kristen Radtke Paul Lee Margret Aldrich John Mesjak Casey Peterson Rosie Phillips-Leav-MC Hyland Katherine Curtis Haruko Tanaka Anonymous Jeremy El-Stephanie Anderson Sara Sestak J. Jaworek Drew Register Northern Martin Maya Singer Aurora Thornhill Diane DeLuca Alicia Cappello Muttamara Mary Margaret Kirby Casey Greene Adair M. Jacobson Awdziewicz Jasmine Rae Friedrich Megan Minier Mark Duros and Sheri field Mira Mehta Susannah McNeely Schouweiler Leda Tilton Lindsay zemnieks Anonymous Don Moyer Lindsey Zellman Lauren Joan Elissa ward McPherson Lynne Carstarphen Erin Edmison Jennie Goloboy Brooks-Sigler Lydia Ondrusek Johanna Baker Kimberly Cope Robin Diem Debra deNoyelles Patrick Nathan Christina Jones Alex Lauer enson Bill Shields Angie Bailey Michael Taeckens Kate Mandel Su-Camille Verzal Nora K. Loyd Laura Kunkel Susan B. Frank Laura Fritz Goebel Kickstarter John Schofield Adam Myatt Valerie Ur-Jena and Brandan Still Karen Inglesby Jennifer and Jason God-Erika Stevens John Dalton Gerhard Moser Teresa Staudacher Doc O'Cat Ethan Rutherford Brandie Younce Jim Walker Brian Lipsey Matthew Rezac Ted Timmons Sheryl Holland Abby Larson Benjamin Sarah Avampato Jessica Kibler Genevieve Ali Scarlett Moser Catherine Heeley Anne Albanese Jacinda Melendez Whit-Beth Rosenberg Jo "minou" Hacker Pamela Johnson Piotr Szy-LaLonde Marjorie Slater Shannon Riebman Sue Taylor Sabrina Caitlyn Herrington Connie Minor Suzanne Hunt Nicola Koester Meredith Pickering Heather Willy Alison Felstead Scully Gloria Walkters Justin Wright Bob Pownall Irene tian Rechlin Summer Drouant Zac Smeltzer Jennifer Osiris Emily Geris Maris Kreizman Stacey Burns Ben-Veken Gueyikian Diane and Michael Kovacs Judy enne Massanari Suzanne Scott Lisa Finkel Friends Cat People Everywhere John Sharp Megan Sullivan da Koutsky Stephen Lewis Janna Rademacher Ben-Daria L. Veccia Eric Oliver Matt Bell Ann Novacheck Riley Hanick Marianne Harding Marguerite Nutter Orozco Laurice Nahas Jeanne L. Sisneros, RN Kath-ly Everding Randall Rupp Paula Newton Maria John-Lea Wade Jen Burke Sarah Schultz Kathryn Ratcliffe-Lee ine Brown David Turkel Catherine Brown Alice Bach Kyle

Katharine Freeman Anon- ymous Jo Shelly Hazard Car- ol Gale Kar-Mack David Daneman le Tate-Casson Yojimbo Jackie Howell Claire Casey Tricia lissa Aho Dawn Oshima Karen Nemchik Pamela

FUNDER ACKNOWLEDGMENTS

Coffee House Press is an independent, nonprofit literary publisher. All of our books, including the one in your hands, are made possible through the generous support of grants and donations from corporate giving programs, state and federal support, family foundations, and the many individuals who believe in the transformational power of literature.

We receive major operating support from Amazon, the Bush Foundation, the Jerome Foundation, the McKnight Foundation, Target, and the National Endowment for the Arts. To find out more about how NEA grants impact individuals and communities, visit www.arts.gov. In addition, this activity is made possible by the voters of Minnesota through a Minnesota State Arts Board Operating Support grant, thanks to a legislative appropriation from the arts and cultural heritage fund.

Coffee House Press receives additional support from many anonymous donors; the Alexander Family Foundation; the Archer Bondarenko Munificence Fund; the Elmer L. & Eleanor J. Andersen Foundation; the David & Mary Anderson Family Foundation; the Buuck Family Foundation; the Carolyn Foundation; Dorsey & Whitney Foundation; the Lenfestey Family Foundation; the Mead Witter Foundation; the Schwab Charitable Fund; Schwegman, Lundberg & Woessner, P.A.; Penguin Group; US Bank Foundation; VSA Minnesota for the Metropolitan Regional Arts Council; the Archie D. & Bertha H. Walker Foundation; the Wells Fargo Foundation of Minnesota; and the Woessner Freeman Family Foundation.

THE PUBLISHER'S CIRCLE OF COFFEE HOUSE PRESS

Publisher's Circle members make significant contributions to Coffee House Press's annual giving campaign. Understanding that a strong financial base is necessary for the press to meet the challenges and opportunities that arise each year, this group plays a crucial part in the success of our mission.

"Coffee House Press believes that American literature should be as diverse as America itself. Known for consistently championing authors whose work challenges cultural and aesthetic norms, we believe their books deserve space in the marketplace of ideas. Publishing literature has never been an easy business, and publishing literature that truly takes risks is a cause we believe is worthy of significant support. We ask you to join us today in helping to ensure the future of Coffee House Press." —The Publisher's Circle Members of Coffee House Press

Publisher's Circle members include many anonymous donors, Mr. & Mrs. Rand L. Alexander, Suzanne Allen, Patricia Beithon, Bill Berkson & Connie Lewallen, E. Thomas Binger & Rebecca Rand Fund of the Minneapolis Foundation, Robert & Gail Buuck, Claire Casey, Louise Copeland, Jane Dalrymple-Hollo, Mary Ebert & Paul Stembler, Chris Fischbach & Katie Dublinski, Katharine Freeman, Sally French, Jocelyn Hale & Glenn Miller, Jeffrey Hom, Kenneth & Susan Kahn, Kenneth Koch Literary Estate, Stephen & Isabel Keating, Allan & Cinda Kornblum, Leslie Larson Maheras, Jim & Susan Lenfestey, Sarah Lutman & Rob Rudolph, Carol & Aaron Mack, Olga & George Mack, Joshua Mack, Gillian McCain, Mary & Malcolm McDermid, Sjur Midness & Briar Andresen, Peter Nelson & Jennifer Swenson, Marc Porter & James Hennessy, the Rehael Fund-Roger Hale & Nor Hall of the Minneapolis Foundation, Jeffrey Sugerman & Sarah Schultz, Nan Swid, Patricia Tilton, Stu Wilson & Melissa Barker, Warren D. Woessner & Iris C. Freeman, and Margaret & Angus Wurtele.

For more information about the Publisher's Circle and other ways to support Coffee House Press books, authors, and activities, please visit www.coffee housepress.org/support or contact us at: info@coffeehousepress.org.

ALLAN KORNBLUM, 1949–2014

Vision is about looking at the world and seeing not what it is, but what it could be. Allan Kornblum's vision and leadership created Coffee House Press. To celebrate his legacy, every book we publish in 2015 will be in his memory.

CONTRIBUTORS

SASHA ARCHIBALD is a writer and curator. Her essays about picture-making, obsolete spectacles, and historical byways have appeared in the *Believer, Los Angeles Review of Books, Modern Painters, East of Borneo,* the *Rumpus, New Inquiry, Mladina, Three Letter Words,* and other publications, and she is a frequent contributor to and former editor at *Cabinet.* She also organizes events, exhibitions, and digital initiatives. She is currently curator of special programs at the Los Angeles arts nonprofit Clockshop.

WILL BRADEN is the creator of Henri, Le Chat Noir, the world's foremost feline existential philosopher. He is also the producer of the Internet Cat Video Festival. He loves cats and bathes using only his tongue.

STEPHEN (sometimes Stephanie) **BURT** is a professor of English at Harvard and the author of several books of poetry and literary criticism, among them *Belmont* (2013), *Close Calls with Nonsense* (2009) and the new chapbook *All-Season Stephanie* (2015). Stephen's essays and reviews appear frequently in journals and magazines, among them *ALH, Boston Review,* the *New York Times Book Review, Rain Taxi,* and *Yale Review.*

MARIA BUSTILLOS is a journalist and critic. Her work has appeared in the Awl, *Harper's,* the *New Yorker,* the *New York Times,* the *Los Angeles Times,* the *Los Angeles Review of Books, OUT Magazine, Details, Aeon,* the *Guardian* (UK), and elsewhere. She has two black cats: a prosperous-looking one named Count Fosco and a slim, elegant old one named Sam.

DAVID CARR was a reporter and the "Media Equation" columnist for the *New York Times*. Previously, he wrote for *Atlantic Monthly* and *New York* magazine and was editor of the *Twin Cities Reader* in Minneapolis. The author of the acclaimed memoir, *The Night of the Gun*, he passed away in February 2015.

MATTHEA HARVEY is the author of five books of poetry—*If the Tabloids Are True What Are You?*, *Of Lamb* (an illustrated erasure with images by Amy Jean Porter), *Modern Life* (a finalist for the National Book Critics Circle Award and a New York Times Notable Book), *Sad Little Breathing Machine*, and *Pity the Bathtub Its Forced Embrace of the Human Form*. She has also published two children's books, *Cecil the Pet Glacier*, illustrated by Giselle Potter, and *The Little General and the Giant Snowflake*, illustrated by Elizabeth Zechel.

ALEXIS MADRIGAL is the editor in chief of Fusion, an ABC-Univision joint venture. He's also a visiting scholar at the University of California, Berkeley, and the tech correspondent for WHYY's Fresh Air.

JOANNE MCNEIL is a 2015 fellow at the Carl & Marilynn Thoma Art Foundation, as the recipient of the Arts Writing Fellowship Award to an emerging writer in digital arts. She is a contributing writer and editor at the *Message*, the technology-focused opinion magazine published by Medium.

ANDER MONSON is the author of six books, most recently *Letter to a Future Lover* (Graywolf, 2015). He edits Essay Daily, *DIAGRAM*, and the New Michigan Press.

KEVIN NGUYEN is the editorial director at Oyster and edits the *Oyster Review*. His writing has appeared in *Grantland*, the *Paris Review*, the *New Republic*, and elsewhere. In a past life, he ran the Best Books of the Month program at Amazon and was the founding editor of the *Bygone Bureau*. He is based in Brooklyn, NY.

ELENA PASSARELLO is the author of *Let Me Clear My Throat* and the forthcoming *Animals Strike Curious Poses*, both with Sarabande Books. A recipient of the 2015 Whiting Award for Nonfiction, Elena teaches in the MFA program at Oregon State University. She and her boyfriend live a couple miles from campus with three weird cats: Charlene, Columbo, and Sharky.

SARAH SCHULTZ is an independent curator and formerly the curator of public practice and director of education at the Walker Art Center. She co-created the Walker's experimental Open Field initiative, which incubated the world's first Internet Cat Video Festival. She lives in New York City and Minneapolis.

JILLIAN STEINHAUER is the senior editor of Hyperallergic and a writer living in Brooklyn. A graduate of NYU's Cultural Reporting and Criticism program, she is the recipient of the 2014 Best Art Reporting award from the U.S. chapter of the International Association of Art Critics. Her work has appeared in *Slate*, the *Los Angeles Review of Books*, the *Paris Review Daily*, the *Jewish Daily Forward*, and other publications. A juror of both cat video festivals and tote bag competitions, she lives with (and over-Instagrams) her two cats.

CARL WILSON is the author of *Let's Talk About Love: Why Other People Have Such Bad Taste*, the acclaimed book about aesthetics, democracy, and Celine Dion. He is the music critic for *Slate,* a contributor to many other publications, the doorman for the Trampoline Hall Lecture Series, and lives with no pets in Toronto.

Cat Is Art Spelled Wrong was designed by Dante Carlos of the Walker Art Center (Minneapolis) and Kirkby Gann Tittle.

Text is set in Genath.